After I Said No

After I Said No

a novel

Sheila Golburgh Johnson

FITHIAN PRESS · SANTA BARBARA, CALIFORNIA · 2000

Published by Fithian Press
A division of Daniel and Daniel, Publishers, Inc.
Post Office Box 1525
Santa Barbara, CA 93102

LIBRARY OF CONGRESS CATALOGING-IN-PUBLICATION DATA
Johnson, Sheila Golburgh
 After I said no / by Sheila Golburgh Johnson.
 p. cm.
 ISBN 1-56474-312-8 (alk. paper)
 1. Jews, Russian—New York (State)—New York—History—20th
century Fiction. I. Title.
PS3560.O38642A69 2000
813'.54—dc21 99-25532
 CIP

For Don

After I Said No

Chapter 1

ONE DAY I came home from my Russian school in St. Peters-
burg to find Aunt Rachel pacing our long hall with frantic steps.
Her skin was flushed, and she almost leaped at me when I
closed the front door.

She thrust a white envelope toward me.

I looked. It was another letter from America, which I recog-
nized by the stamps before I even glanced at the writing. It
could only be from my Aunt Heddie, who had emigrated from
Russia twelve years ago.

"So what's new with her?" I shrugged. Probably more brag-
ging about how well her boys were doing in school and how
many parties she was invited to.

"But it's not addressed to me," Aunt Rachel said. "It's
addressed to your father. Whatever can she have to tell him?"

I looked again and sure enough, there was my father's

name, Samuel J. Sokolov, in Aunt Heddie's heavy, round script.

I threw down my books and went into the kitchen for the hot tea that Cook always had waiting. But the thought of the letter nagged me. For twelve years Aunt Heddie had been faithfully writing letters to Aunt Rachel. She would read them to me, and we would chat endlessly about all the new things my American cousins were doing, and all the naughty things, too. And there were pictures. Although Heddie and her family had left Russia the year I was born—strangely enough, the day I was born—I had a good idea of what they all looked like.

Aunt Rachel always read parts of these letters to my father. If he were away on the continent on a business trip, she would wait and read the "important" passages to him at dinner when he returned. I noticed that what she read to my father was not what interested us; she tactfully left out Aunt Heddie's complaints about her health or the color of her new carpet. She read my father the parts about Uncle Joseph Edelman's prosperous insurance business and about my cousin David's success in school. But never once, in twelve years, had Aunt Heddie ever addressed a letter to my father.

Aunt Rachel plunked down opposite me at the kitchen table. She stood up again and paced around it, leaning heavily on the chair backs for balance. The second child born to my Grandfather Sokolov's marriage, she had arrived in the world with a twisted leg, and limped badly.

"Whatever can it be?" she muttered. She held the envelope up to the watery sunshine streaming through the window and squinted to catch a few lines of the writing inside. "Do you think something terrible happened? Something she'd rather tell Samuel first?"

"Ah, no," I said. "I think if something terrible happened she would write to you, Aunt Rachel. She'd let you tell papa. She tells you everything."

"Well then, we just have to wait until Samuel comes home tomorrow night."

I drained my glass of tea. "No we don't. Why don't you open it? Just tell Papa the parts you think he wants to hear, the

way you always do. He'll never know the letter was addressed to him."

"Perele!" She cocked her head to the side. "Is that what you learn at school, where your father spends so much money to send you? To lie to your own family? How could you think of such a thing?"

"Oh, I was only joking," I said, but I really meant it.

For a long time I had known that my father's heart belonged to the sparkling jewels he bought and sold. Precious metals and gems were a tradition in my father's family. My grandfather, Avrom Sokolov, had been summoned from his country village by the tsar himself because the silver buttons Avrom made were so beautiful. My father had always been fascinated by the metal work in his father's St. Petersburg shop. From learning to make buttons, he went on to help the goldsmiths repair or set the occasional pieces of jewelry that customers brought in. My father fell in love with the gemstones: sultan red rubies, icy diamonds, cat's eye topaz, lapis lazuli, and many others.

When Avrom gave up his shop to open a button factory, Samuel decided to stay in the jewelry business. He petitioned the tsar's commissioners for a permit to travel outside the borders of Russia. Nobody was allowed to travel outside Russia without special documents, but with my grandfather's connections and pay-offs to a few highly placed officials, my father obtained the important documents. He traveled throughout Europe buying precious jewels. He brought them back to Russia, mounted them, and sold them at good profit to the rich and titled nobility of the St. Petersburg court.

After my mother's death he had asked Aunt Rachel to come live with us, and soon he lost all interest in family matters. Often, I was afraid to be alone in my room. What if the Angel of Death came for me, too? Aunt Rachel would sit beside my bed until I fell asleep still clutching her cool, smooth hand. If I woke up crying in the night I would hear the thud of her crippled leg almost immediately. She was at my bedside in a few minutes, first waking one of the servants to bring us glasses of warm milk or hot chocolate.

I thought it would be appropriate if any unpleasant news

was first filtered through the kind eyes of Aunt Rachel, but it was impossible. She turned pink just thinking about it.

Dinner that night was a gloomy affair. Aunt Rachel propped the letter against the water glass before her plate. She continued to examine the envelope while we ate our sweet and sour cabbage soup with boiled beef. She seemed to believe that if she stared at the envelope long enough it would give her some clue to what was inside. I was curious, also, but I did not consider the affairs of Joseph and Heddie Edelman of first importance in my life.

After our dessert of stewed fruit, Aunt Rachel still wallowed in gloom. I challenged her to a game of chess to cheer her up. When I saw she was so distracted that she let me capture three of her important pieces during the opening game, I couldn't keep still.

"Why are you so worried, Aunt Rachel? Do you think someone in the family is sick?"

"God forgive me, but I hope that's all it is," my aunt said. "I love my sister dearly, but you don't know how she is. How could you? You never knew her."

"How *is* she?" I demanded. "You never tell me the truth about her. Is she mean? Is she selfish?"

Aunt Rachel bit her lip. "I'll never forget how she was at your mother's wonderful wedding, Perele. It was such a grand affair. Your mother's father, the rabbi, came in from the village with your grandmother and their seven sons. They were very poor, but nobody minded because the rabbi was such a pious man, and your mother was a darling."

"Yes, yes, tell me again how she knew Russian even though she grew up in a village."

"The rabbi was so pious that he wouldn't let his sons go to the state school. He paid the registrar to leave the names of his boys off the roll, and he tutored them himself at home. Of course it was not considered necessary to educate girls in the village. But your mother was eager to learn, and demanded a tutor for herself.

"The rabbi was a good-natured man, and he adored his only girl. When she was eight years old, the rabbi found her a

teacher and she studied Russian, German, and singing. This teacher refused to accept any pay for the honor of teaching the rabbi's daughter."

"But you have never told me how my father found my mother. He always lived in St. Petersburg."

"Don't forget, Aunt Heddie had already married Uncle Joseph. She ran her household as if she thought she were the tzarina herself! My brother Samuel felt sorry for Joseph. When Samuel decided to marry, he wanted someone brought up in the old way, where the man was considered the head of the family. He told his father, who went to a *shadchen*. A *shadchen* is someone who arranges marriages, and she tried to please both parties. People still use them. He asked her to find a gentle girl, kindly brought up, who would be grateful for the life she would have in St. Petersburg. Within two months the *shadchen* had located your mother."

Aunt Rachel paused and moved a chess piece out of the way of capture.

I stared at the board, but I was too taken up with the story to pay attention to the game.

"So what happened at the wedding?" I persisted.

"Oh, it was such a wonderful wedding! My father spent a fortune on the marriage of his only son. Crystal, linens, household goods of every kind were provided. Mother and I crocheted yard after yard of lace to trim the best sheets, and maids sewed silk coverlets for the new featherbeds. The guest list included some of the oldest Jewish families in St. Petersburg; people your grandparents had known for many years. The men turned out in silk frock coats, and the ladies in all their satins and jewels."

"But what about Aunt Heddie?"

"Everyone danced and feasted to share the joy of my happy brother and his bride," she went on. "But there was one couple who sat on the sidelines; that was Heddie and Joseph. And Joseph is a kind man. He kept trying to cheer up Heddie even though it was impossible. She was carrying her first child in her belly like a little fish. You couldn't tell yet, of course, but she had gained weight until she was very fat, and her skin was yellow."

I started to giggle, but my aunt frowned.

"It didn't seem funny to her. She suffered from high blood pressure and indigestion, and was in a horrible mood the whole nine months."

"But wasn't she happy that Mamma and Papa were getting married?"

Aunt Rachel hesitated a moment. "I don't think so, Perele. I think she was jealous. Your mother was a perfect vision! She was beautiful, and glowing with that healthy look girls have who grow up in the country. Heddie seemed to turn green every time she looked at your mother. When Samuel and his bride were dancing, I went to Heddie to see if I could bring her some cake or wine. And do you know what she said to me? I've never forgotten, even though I tried."

"What did she say?" I asked. Suddenly the chair I was perched on tipped over, spilling me on the floor.

"Sorry," I said, picking up the chair. "But what did she say?"

Aunt Rachel screwed her face up into a mask of spite. "She said, 'Samuel's wife will never have anything I can't have.' And she looked like this when she said it! My heart shriveled inside me, but then I remembered how uncomfortable she was. We all helped her as much as we could through her pregnancy. But she never felt well, and suffered a lot."

My aunt sighed. "And now she's had three more boys in America, without me there to take care of her! I hope they were easier than the first."

When I returned from school the next day, my father was home from his trip. I could see him through the gauzy layer of curtains in the drawing room, talking earnestly to Aunt Rachel.

I bounded into the house and threw open the drawing room doors, which were not supposed to be closed at that time of day. Aunt Rachel turned. She and my father stared at me.

"Oh, Papa!" I ran to give him a kiss on each cheek, as was our custom. "Did you have a good trip? Did it rain a lot? What did you bring? Chocolates from Switzerland? A new French doll? A silk hat for Aunt Rachel?"

My aunt threw up her hands. "Look at her, Samuel, she's just a child! What can Heddie be thinking of?"

I jumped off the sofa. "What *is* she thinking of?" I demanded. "What was so important she had to write to Papa?"

They stared at each other until my father broke the silence. "We have to tell her, Rachel. It concerns her, after all."

I remained standing, hands on my hips and elbows stuck out. Suddenly I knew what Heddie wanted. Hadn't she sworn that my mother would never have anything that she, Heddie, couldn't have?

Aunt Rachel put her arm around my waist gently, and drew me to her breast. "Heddie thinks she's still in Russia, where girls are promised in marriage while they are still children, darling. I've heard things are different in America, but twelve years there haven't changed her. She wants...she wants us to betroth you to cousin David and send you to America!"

I burst into tears and buried my face in Aunt Rachel's shoulder. She was mother and aunt and sister and protector, all in one.

"I won't go!" I shrieked between sobs. "I won't leave you. Don't make me! I won't go!" I caught my breath and glared at my father with all the terror in my heart. "I'll jump over the side of the ship."

"She's hysterical," my father said. He rose and shook his head. "We can't talk about it now. I can't even think about it now." Slowly, like a tired, old man, he slouched out of the room.

Aunt Rachel hugged me close. Our tears fell together and soaked her shoulder.

Chapter 2

I DID NOT go to America when that letter from Aunt Heddie came. I was only twelve years old, and both my father and Aunt Rachel thought I was too young. Although they had a vague plan to join the Edelmans in America someday, there was no particular reason to leave just yet. Life was peaceful in Russia, and there had been no anti-Jewish riots for twenty years. There was a new tsar on the throne, and everyone was hoping for improved conditions. Meanwhile, I did well in school, my father did well at his business, and Aunt Rachel was content taking care of us.

Two years after we received Heddie's letter asking my father to betroth me to David, there was a terrible riot in the city of Kishinev. Thirty bands of hoodlums attacked Jewish residents with unspeakable violence and gained control of the railway station so none could escape. Horror stories spread quickly, and by

the following year many Russian Jews who had been thinking of emigrating for a long time set out across the sea to America.

A trickle of these people had been migrating to the United States for twenty years. Many had become citizens and had established themselves in different occupations. The new Americans wrote enthusiastic letters, full of the wonders of their new lives, to their families who remained in Russia. They urged their friends and relatives to join them, to start life over in a country where all people were equal before the law, and where anyone with a desire to work hard could earn a decent living.

These letters were passed from hand to hand. They were read at parties and factories, discussed by market women in the stalls and by businessmen over their accounts. Even little children at play pretended to cross the sea and settle in a new land. Yet still we didn't leave. It may have had something to do with the fact that my father had never been too fond of Heddie. She would have been our only contact in the new country. It may have been that in every letter, Heddie gloated over what a wonderful couple David and I would make, and how much she and Joseph could do for me.

"Perele will be our own daughter," she wrote.

Aunt Rachel and I would look at each other and smile. With her usual tact, Rachel had written that their brother thought I was much too young to even consider betrothal. That didn't seem to discourage Heddie.

Meanwhile, conditions for our people in Russia were growing worse. Attacks and restrictions on Jews increased in number and ferocity. People we knew spoke of little else, and I even felt it at school. Once we Jewish students had mingled happily with Christian friends, but now we kept to ourselves. When we were chatting in the halls and the other girls approached, we fell silent. It became hard to look Christian girls in the eye, and we found they avoided us, too.

Eventually I grew so unhappy that my father withdrew me from school and hired tutors to come to our house. I started to study English at this time, but I'm afraid the tutor didn't know it too well himself, for I learned some very odd English phrases. I didn't discover this, of course, until I was in America.

Our social position protected us from a great deal that was going on, but it could not protect us forever. My father, a member of one of the wealthiest families in St. Petersburg, was followed home from the train station one night by a gang of hoodlums who threw showers of stones. They taunted him with demands for the gruesome death of all "bloodsucking Jews."

By this time I was fourteen years old, and nobody thought I was too young to be betrothed or travel to America. We had been talking about the move for years, and when the Bialystok pogrom occurred, it was the last straw for my father.

"Perele, you will go first. Heddie will be thrilled to receive you as her future daughter-in-law," he announced one night. We were sitting around the dining table after dinner.

"It will take a while for us to join you. I'll find new positions for some of the servants, and set up pensions for the old ones. Rachel, you'll take care of all our personal things and prepare to close up the house." He sipped the last few drops of his tea and squinted into the candle flames' glow.

"I want to find an enterprising young man to take over my business. After all, I have contacts in Europe that took many years to cultivate. I didn't build this for nothing. Maybe one of your mother's brothers could be trained...."

He stroked his mustache for a few minutes, while I digested this news. His eyes were moist. If I had not been so wrapped up in my own thoughts, I would have felt sorry for him. Buying and selling jewels had been his whole life, and now he would give it up.

I jumped from my chair and ran to throw my arms around Aunt Rachel. "Oh, why can't she come with me?"

I made my eyes big and round, and looked pitifully across the table at my father. "I don't even remember Aunt Heddie! I don't want to go to strangers!"

"No, no, darling," Aunt Rachel said. She stroked my hair until it flowed like a cape. "How could you remember her? She left for America the very day you were born. Of course we won't send you to strangers! I have been writing to her ever since you were a healthy baby, and I sent those letters off the minute I had her new address. She knows you as well as I do, and loves you just as much. Strangers, indeed!"

"Come on, Perele," my father said, scowling. "You're fourteen years old. When your mother was fourteen she was helping to take care of her seven brothers as well as studying Russian. And German, too! And she was just a little bit of a girl."

Hot tears gathered behind my lids and rolled slowly down my face. My aunt drew a silk handkerchief from her sleeve and wiped them away, gently.

"Samuel, she's still a child. I know you need me, but let me travel with her at least to the Russian border. I'll put her on the train to Hamburg, and then I'll come back. From Hamburg it will only be a matter of boarding the ship. When she gets off the ship in New York, Heddie will meet her."

My father shrugged. "If you think it best."

"And Papa," I said, feeling him beginning to soften, "my birthday is in two months. Can't I wait until then, so I can have a party with Devorah and Fanny?"

He looked helplessly at Rachel, who nodded vigorously.

"All right, then," he said. "In September you leave, right after your birthday. Rachel, write to Heddie and tell her that Perele and David are officially betrothed."

"Yes, of course," Rachel agreed. She smiled and gave my arm a hidden squeeze. Then she picked up the silver bell that stood beside her plate, and rang for Marya to come clear off the table.

I watched the old woman toddle in on her arthritic legs and slowly pile a tray with the dirty dishes. She was a twisted crone with long fingernails as grooved and bent as a ram's horn. Her hands used to scare me when I was little, but she had never shown me anything but kindness. I could not stand the feeling of fat in my mouth. She always spent extra time trimming my meat for me, even when my father would say, "Harrumph! Such pampering!" whenever he caught her at it. I wondered who would pamper me in my new home in America.

I did not wonder what it would be like to be betrothed to cousin David. My imagination simply didn't stretch that far; and anyway, I had a hazy idea of marriage. I had never observed the marriage of my parents. My mother had died in childbirth with her second child, who didn't survive the birth.

That happened when I was five years old. The few friends Aunt Rachel spent time with tended to be unmarried ladies like herself.

I considered "betrothed" a very vague term, anyway. If I thought about it at all, I assumed I would live on in that condition for years, betrothed as long as I wished. I did not understand how serious and binding a betrothal was.

The next two months were very full. My father decided that English was the most important subject for me to study, and he increased the hours I spent with the tutor from ten to twenty hours a week. I had to give up a lot of time I would rather have spent playing with Aunt Rachel's new Swedish sewing machine. I loved the machine, and had figured out how to use it myself. I had already sewn aprons for every woman servant in the household, and I wanted to try something more complicated.

When she saw how hard it was for me to spend all my time studying, Aunt Rachel worked with me on my assignments. She would have to know English sooner or later, anyway. What fun we had with my workbook when we finally mastered the spelling of "thought" and "tot" and discovered the two words rhymed!

There was the matter of clothes, too, because I didn't have a travel outfit. We studied the fashion magazines that my aunt ordered from Paris, and decided on a long traveling cloak with a hood I could raise to protect me from the rain that fell constantly in both St. Petersburg and Germany. St. Petersburg is on the Neva, a river that empties into the Gulf of Finland. The climate is cold, windy, and damp. As for the new country, we heard that it was cold in the winter and hot in the summer. For my traveling cloak, we chose a green wool in a lovely shade that reminded me of the northern forests, with a blue-green lining to match my eyes.

My birthday party was a half-merry, half-solemn affair. Old Marya served the chicken Kiev with tears in her eyes. She knew she would not be serving me much longer. My two best friends, Devorah and Fanny, fell to giggling when they discovered that they had each chosen the same gift—embossed leather portfolios containing sets of paper and envelopes so thin I could see through a sheet when I held it up.

Aunt Rachel presented me with a handsome brass-bound leather trunk fitted with a removable tray. She said it would hold my dowry after I was settled in my new home.

When the party was over and Marya was sweeping up the last crumbs from under the table, Aunt Rachel went up to bed complaining of too much rich food. My father led me into the drawing room, motioned me to sit down, and handed me a tiny velvet box of midnight blue. A pair of round diamond earrings nestled in the silk lining, glittering like ice on the Neva in winter.

"Oh, Papa," was all I could say.

He proceeded to pace back and forth in front of me, pulling at his thick beard.

"Perele," he began, "I had those earrings made up specially for you. They are worth a great deal, and I hope you'll wear them all your life. But remember, if you're ever desperate for money, any jeweler in the world will be glad to buy such a pair of stones. Diamonds speak an international language. These are some of the finest I've come across."

"Thank you, darling Papa," I exclaimed. "But why should I need money? We all know how well Uncle Joseph's business is doing. My cousins have everything they could ask for. Why do you think I would need money?"

I touched the cool diamond nestled in my right ear. "I love them, Papa, and I will never sell them."

"Ah, yes, but it's an uncertain world that we live in, child. And you are going so far away...."

I jumped up and threw my arms around him. "Oh, Papa, hurry up! Take care of your business! I want you and Aunt Rachel to come soon."

"We will, little sparrow. We will," he murmured, and stroked my hair. "We will think of you every day until we see you. And we will pray for your happiness."

I buried my head in the rough wool of his jacket. "I want you to come now," I said, but I don't think he heard me.

Chapter 3

THE TRAIN TRIP to the German border was fun, as every-
thing was with Aunt Rachel. I felt very adult with my three
trunks and my handsome green cloak that brushed the floor
when I walked. We had an enclosed compartment, and I spent
some time watching the scenery out the window. Our trip took
more than a day and a night, and sometimes Aunt Rachel
would entertain me with stories of my grandfather's hands.

"My father had what we used to call 'golden hands,'" she
said. "He could do anything with them, Perele. He could repair
watches, forge new links for chains, and carve the most beauti-
ful chess pieces! I learned to play chess with one of my father's
sets."

She stared out the window at the forest flying by. "The
kings and queens had long robes and crowns carved with stars.
The little knights were mounted on horses with wild manes.

And of course, his silver buttons, the most beautiful in the empire. Even now, after his death, the button factory he built uses designs he created when he was only a poor village silversmith. Tsar Nicholas knew he had to have my father's buttons the moment he saw them...."

I always loved to hear Aunt Rachel's family stories, but this time I had trouble paying attention. My head was full of New York, and all the wonderful things I would see there. In her last letter, Aunt Heddie had promised me piano lessons. They ate out at least twice a week, since it was the latest fashion. I wondered if my English would be good enough, and if I would make new friends. I knew there were many Russian Jewish girls in New York, maybe even some from St. Petersburg.

At dusk we ate the cold food that Cook had packed for us, and tried to sleep when night fell. The dawn light awoke Aunt Rachel from her uncomfortable doze. She yawned, stretched her arms, and got up to use the water closet. I had grown up with her and seldom noticed her limp, but that morning it seemed that she could hardly stay on her feet as she lurched down the narrow, swaying corridor of the train. Every time she lunged for balance I caught my breath, it hurt me so.

When she came back we had to review, yet again, everything I had in my traveling case: my money, passport, steamer ticket, Aunt Heddie's address in New York in case she was not there to meet me, Papa's and Aunt Rachel's names and where they could be reached in St. Petersburg in case I had an accident, and a medical report from a Russian doctor. I would have to submit to at least two more medical examinations before I would be allowed to enter the United States, but Aunt Rachel had thought it best to have papers to show, testifying to my excellent health.

At the town of Versbolo, the last station on the Russian side of the border, a German doctor and several Russian *gendarmes*, or policemen, entered the train. They went up and down the aisles checking everyone's passport and travel arrangements. They asked many questions about my destination and my health, and seemed impressed when I showed the letter from our own doctor in St. Petersburg.

"And you, Miss Sokolov?" the doctor asked Aunt Rachel. "Do you have any infirmities you should report?"

"I am only traveling this far with my niece," she said. "I would like one of the *gendarmes* to be sure she is put on the train to Hamburg. She'll take a steamer from there."

"You will have to leave the train then, miss," the doctor told her. "You can get a train back on track seven. All these passengers will continue on to Berlin to be processed. They'll be routed to Hamburg from there."

"Then it is good-bye," Aunt Rachel said softly, enveloping me in her warm, fur-lined cape. She pressed me to her breast, kissed me on both cheeks, and rose to leave.

"No!" I screamed, clutching at her sleeve, but it was no use. One of the *gendarmes* pinned me to the seat with his baton, and I could not follow her. The last word she spoke to me was my name, "Perele," very gently, as she turned to wave a last good-bye. But she was so unbalanced on her twisted leg that she would have fallen if one of the *gendarmes* had not caught her by the arm and steadied her.

"Hhhhhhnnnnf!" muttered the doctor, and said something to the other men in German. They sighed and shook their heads, while I gulped down sobs and wondered what he said about my dear aunt.

After we sat on the train for about an hour the walls began to feel as if they were closing in on me. The officials went up and down the aisles telling all the passengers they had to change trains. We were directed to the baggage room to wait, where there was enormous confusion. Boxes, baskets, valises, and trunks, as well as shapeless packages wrapped in cloth were thrown about by porters as they attempted to match each one to its owner and affix tickets. Fortunately, we had heard this happened more than once on the journey. Aunt Rachel had tied brightly colored scarves on the handles of my trunks that now stood out among the mountains of baggage. I was able to offer my ticket stubs and point out my own things to a porter as soon as I could find one free and get his attention.

When the confusion showed signs of letting up, we were directed to board another train along with all our things. There

was only room on the floor for our luggage and some narrow benches along the wall, so most of the passengers, including myself, sat rather uncomfortably on bags and trunks. I had a first-class ticket, but I decided not to say anything about it to the conductor. If going first class meant waiting for another train, I preferred to jam myself in with everyone else and at least be on my way.

Late in the afternoon we entered Berlin. What a rush of trains passing, beautiful buildings, shops with gaudy wares that were only a bright blur through the train windows; and everywhere, crowds of people, horses, and dogs. What a din all this made! Hammers, bells, whistles, sirens screaming, men shouting, children crying, horses clomping, all mingled in a deafening blast of noise that went on and on.

The train rolled through the city and stopped in a lonely field on the outskirts. We were told to leave the train, then herded into a huge building by white-clad Germans. Someone separated us into groups of women, men, and children. Many of the children screamed and howled at being separated from their mothers, but soon we could not hear them. We women were taken behind drapes and told to remove our clothes. We were rubbed all over with soap, our hair scrubbed, and a shower of warm water let down upon us without warning. Then, wrapped in great, fluffy towels, we were taken to another room where we waited for our clothes, thoroughly steamed, to be returned to us. At a time when deadly cholera and other epidemics were impossible to control, the officials were taking no chances that we would carry diseases into another country.

When everyone had been thoroughly disinfected, we climbed aboard yet another train and set out for Hamburg, where we would find the ship waiting that would take us to America. Or so I thought.

Nothing was that easy. Before we could board the ship, we were once again lined up, questioned, labeled, and pigeonholed. I saw people turned back who had made the long journey from some miserable village in Russia, who showed in their desperate faces they had no way of getting back. Or perhaps they had nothing to go back to.

The rest of us, those who passed the physical examinations and whose papers were in order, were subjected to one final ordeal called "quarantine." We were required to remain in huge brick barracks surrounded by a stone wall. We would stay there for two weeks, the length of time it would take any horrid diseases to show themselves. Of course we were provided with regular meals and a place to sleep at night, but we had to answer roll call every morning and night as if we were prisoners. We were, in a way.

I was not uncomfortable in quarantine. I might have relaxed and made some friends, but there were many languages spoken, and most of my fellow travelers were so eaten up with worry that it was hard to talk to anyone. As it was, I passed the days in an agony of impatience for the moment I would set out across the ocean. There was no going back, and I was so tired of standing still!

The time came at last. We filed onto the great German liner, the *Kaiser Wilhelm*, where a porter carried my best trunk to the stateroom I would share with another person. My other trunks went into the hold. I jumped up and down on the bed to make sure it was comfortable, found that it wasn't, and located the lavatory, which was used by several other staterooms. I threw on my cloak and rushed out to the deck, where I could watch other passengers boarding. After what must have been several hours, the workmen rolled away the steps, the whistles blew—and I felt a sharp lurch as the grand ship began her long voyage west.

Once we were underway, I relaxed. I hung over the railing for hours and hours watching the waves in all their moods and tempers. Sometimes they were purple and angry, and sometimes they were green and calm. Once or twice the ocean looked like glass, it was so smooth. I did have one bout of seasickness on the third day out, when the ship tossed and pitched as if it were trying to dislodge its unhappy passengers. My cabin mate, with whom I had hardly exchanged two words, made soothing noises and brought me fresh water to sip. She said it was important not to become dehydrated. She was the first person who acted as if I were a real person since I left my aunt at the German border, and I almost wept at her kindness.

She was a girl a little younger than I, with a thin, pale face and narrow shoulders. Her name was Frieda Lewitz, and she was also traveling to join the family of a man she was betrothed to. She had never met her fiancé, either.

By the fifth day the sea was smoother, or at least I didn't notice the tossing so much. Fog enveloped us. I listened to the gloomy foghorn and imagined it was the hoarse call of some monstrous sea dragon, about to rend our ship in two with one gnash of his ivory fangs. I thought about my aunt now as I felt the great ocean grow wider and wider between us.

Frieda and I lay on our beds in the evening and chatted in Russian. I was glad to have a friend, especially one so agreeable. We giggled together over what our sweethearts might look like, what their tastes in food and music might be. I told her that my cousin David had lived in America since he was three years old.

"He'll be a stranger," she mused, "even though he is your cousin. My Michael went to America only four years ago, but he is from Minsk, so I never met him. His family found me. They were looking for a city girl from Moscow, with a good dowry. His father has a grocery store in Boston, where Michael works." She screwed up her pretty face. "I never dreamed I would be a grocer's wife, but that's what my parents wanted."

"What would *you* have wanted?" I asked.

"Oh, I!" She sprang to her knees on the bed. "I would have wanted a horse breeder, with a stable full of white horses that we would ride through the wind every day."

She looked at me slyly and giggled. We both knew it was impossible; neither of us had ever known a Jewish horse breeder. We exchanged the addresses of where we were heading and vowed to write to each other after we were settled. No matter how long we were separated, I knew we would find each other again someday. I fell asleep that night with the sweet feeling that I already had one new friend in the strange land.

There were days when the sun shone brightly on the billowing waves and my spirits echoed this brightness. On these days, Frieda and I spent a lot of time on deck playing a popular game of cards called "Skat" with other passengers. Most of them were also young people, for emigration calls to those with life

ahead of them. We shared our hopes and plans and tried to soothe each other's fears. Sometimes a band played music, and we danced until the blood rose high in our cheeks and we fell panting into deck chairs, giddy with high spirits.

Finally, we approached the shore of our destination. We all crowded on deck for our first sight of that great statue, the "mother of exiles" that we had cherished in our hearts throughout the journey. A wild cheer arose when we first glimpsed her graceful form rising from the sea.

It took most of the day to get through inspections, another health examination, a careful study of our papers, and other endless delays. After an agony of dragging hours I was allowed into the waiting room, where I hoped my family waited. I scanned the faces and passed right over a heavyset woman with a twist of auburn hair piled up under a wide-brimmed black hat. A plump young man who looked almost twenty, with great sparkling dark eyes and a shadow of a beard beneath his sulky mouth, was seated beside her. He met my stare and half smiled, half frowned. I studied the woman beside him again. It was my Aunt Heddie!

At that same moment she must have realized who I was, for she flew from the bench and grabbed me in hungry arms.

"Perele! Perele!" she cried in Russian. "I've waited for this for so long!"

Chapter 4

ALTHOUGH IT was only six o'clock when we arrived at Aunt Heddie's house, I was shown directly to my room. I had been unable to utter a word in the taxi.

When I had washed, changed into a nightgown, and clambered into the high, four-poster bed, I was so overcome with exhaustion that I was sucked instantly into a thick, black blotter of sleep.

Sometime the next morning a knock awakened me. A silent maid in cap and apron entered, carrying a tray of chocolate and rolls. My sleep had been so profound that my mind was washed as clean as a beach after high tide. For a few seconds I imagined I was in my own room in St. Petersburg.

I watched the maid set the tray on a table beside my bed. She went to the window, pulled open the flowered drapes with one emphatic gesture, and marched out again. All I could see

from the bed were the tops of other buildings, with windows that looked like the one I was looking out of. I jumped from the bed and bounded nearer to the window. There was a long street of row houses, each one the same, and each with a tiny flag of green grass and shrubbery beside the front steps.

The floor beneath me held firm and solid. My legs recalled the sensation of a rolling deck swept by fresh sea breezes. The last few weeks came rushing back. I was overwhelmed by that great distance between me and my home in St. Petersburg— the distance I had just traveled, hour by weary hour. Rutted roads, train tracks, and empty ocean pressed in on me from all sides. I clambered back into bed and pulled the covers over my head.

Eventually, Aunt Heddie came in to find out if I were "alive or dead," as she put it. At her urging I managed to wash and dress.

"Gloomy" is the only way to describe my first impression of Aunt Heddie's house. The downstairs rooms were filled with heavy pieces of mahogany furniture that gathered darkness, and maroon velvet drapes absorbed what little light filtered in. In one corner of the parlor was a massive grand piano that Aunt Heddie promised I would soon "play like an angel." Even the chairs, upholstered in needlepoint, seemed to loom and threaten.

We sipped tea in her kitchen.

"Did you sleep well?" she asked.

"Yes."

"Now tell me, how are my brother and sister? Rachel writes to me often, but it's not the same as seeing her. Does she manage to get about? Is her leg getting worse? I worry so about what she will do if your father marries again. How does she look?"

"She looks beautiful," I said, fighting back tears. I couldn't stand to think anyone felt sorry for my dear, distant aunt. "She gets about very well. And you don't have to worry about Papa marrying. All he's ever interested in is work and travel. We hardly see him ourselves.

"Oh, my poor darling! You had no mother, and now no fa-

ther! Thank God you're here. We will be the family you've always wanted."

She rose from her seat and grabbed me, pressing me close against her breast. The strong smell of her cologne left me slightly nauseous.

I felt a tiny kernel harden in the center of my back. "I *have* a family. Papa and Aunt Rachel are my family."

"Of course they are, darling. But we are your family, too. You mustn't forget that. When will they come?"

"As soon as Papa can find someone to take over his business. And Aunt Rachel is finding homes for the servants so she can close up the house. I guess they'll be ready to travel in a month, or maybe less."

"Wonderful!" she exclaimed. "We have so much to look forward to! Meanwhile, we'll go shopping. You'll need some new clothes to wear in your new country."

"I brought lots of clothes. We picked them out specially."

"Yes, but you'll want the latest fashions here. And I must call a speech teacher to help with your English. I know just the person! A lovely lady named Mrs. Tumeroff. She's single. Nobody knows what happened to her husband—whether he died, or what. Here in America we call ladies like that 'grass widows.' Hah! Not exactly a flattering term. But that doesn't matter. She'll be perfect."

Aunt Heddie stopped to take a quick sip of her tea, and ran one finger along the stove. "Look at that! Not a speck of grease! I don't know what we'd do without our Zivia." She ran another finger along a shelf of plates, and examined it carefully. Apparently that passed inspection, too.

"Anyway, Perele, it's October now. School has been in session for a month. I think you should work at home for a while before you start the public schools. If you work hard—I'm sure you will—you'll be ready to enter high school next September."

"But, I've been studying English...."

"Oh, did I tell you?" she rattled on, with one of her rapid shifts. "David has already been accepted at Columbia Law School. Isn't that wonderful? He'll start in the fall. We're all so proud! And you'll be here for his high school graduation. It

seems his *bar mitzvah* was just a few years ago! Everything is working out just as I hoped."

She drew back a little and scrutinized me, examining me carefully. "Who do you look like? Most like my mother, I think. She had those blue-green eyes, and that curly brown hair. You have her Cupid's bow mouth, too. No wonder I love you so much."

I could only avoid her eyes, a lump clotting my throat. The people I loved were still in St. Petersburg, an ocean away. I had lost my real mother and knew how delicate the wispy roots of life are.

"Ah, but you must rest today," she said, sensing my weariness. "Tomorrow we will go shopping together. Do you think you'll want to come downstairs for dinner tonight to meet the boys? They're all in school now, of course. Uncle Joseph will want to see you, too."

I couldn't speak.

"Come," she said, taking my hand, "I'll show you around the house, then you can rest. Zivia will be up later to see if you'll eat with us tonight, or if you'll want a tray."

It was actually two nights later, on Friday, that I made my appearance at the dinner table. I had not seen the boys, but I heard them as they clomped upstairs to their rooms on the third floor, and when they shouted to one another in their loud voices. It seemed I heard their footsteps constantly above my head. I heard the tinkle of the piano as they practiced their lessons in the late afternoons, after I had already escaped to the shelter of my own room.

On Thursday afternoon, Aunt Heddie and I went shopping for the clothes she insisted I needed. "Sailor suits" were very popular for both girls and women, and we bought several of these. They had gored skirts that flared below the knee, and blouses with sailor collars that were trimmed with contrasting ribbon. Some of them had anchors embroidered on the sleeves and the front inset. My aunt insisted on buying me a pair of tan goatskin shoes with patent leather toes that buttoned up the side.

Although she wanted to buy me several sets of underwear,

also, I protested that all the undies in my trunk were brand new and quite sufficient. This was not good enough for Aunt Heddie. She dragged me to the ladies' lingerie department and badgered the sales clerk into holding up endless petticoats and chemises for my approval. Feeling tired and nasty by this time, I told her in my slow, awkward English that I hated them all and wouldn't wear a single one, no matter how many she bought. Embarrassed in front of the saleslady, she finally gave it up.

Laden with boxes, we hailed a taxi and glared at each other all the way home. Again, I was too tired to eat with the family.

On Friday night, just as the street lights beyond my window blazed up in the gathering dusk, I went downstairs for dinner dressed in one of my new sailor suits. It was the beginning of Sabbath. The long table in the dining room was set with a damask cloth. The ceremonial *challah*, a loaf of braided egg bread, rested under a cloth between the candlesticks.

While every person at the table stared, I took my seat where Aunt Heddie motioned me, between my cousin David and one of the younger boys. I could see why she had written so often of her longing for a daughter. Among the four sons, plus Old Mr. Edelman, who was Uncle Joseph's father, and Uncle Joseph himself, I felt as if I were in a men's club where I certainly didn't belong. David refused to look at me. His three younger brothers stared. Uncle Joseph, handsome in his embroidered skullcap and black beard at the head of the table, raised a glass of wine as I sat down.

"Perele, you are a true daughter in this house. You are as pretty as your mother was, and well named. You will be a precious pearl to us, bless your heart." With that he raised his glass and sipped. Old Mr. Edelman, David, and Aunt Heddie followed his example. The three younger boys, one about ten and two little ones, simply continued to stare.

"Come now, it is time to welcome the Sabbath as well as Perele," Aunt Heddie said. She chanted the blessings in Hebrew and lit the candles, then called to Zivia in the kitchen. As soon as Uncle Joseph said the blessing for bread and cut the *challah*, we were served steaming bowls of fish soup. The rich broth tickled my nostrils with such a delicious fragrance I felt faint. I

remembered that I had eaten nothing but endless cups of tea and poppyseed cookies since I had arrived two days ago.

"How was your trip, Perele?" Uncle Joseph asked. "Did you find it hard to travel by yourself?"

"Aunt Rachel came with me as far as the German border and left me on the train. So it was only part of the way myself. She stayed on the train with me for a few minutes. Then she had to leave."

I paused, afraid I was talking too much. Papa used to say children should not chatter constantly, but everyone at the table was staring at me.

"There were endless medical examinations," I went on after a while. "I never saw so many doctors. One of them muttered something in German about Aunt Rachel when she limped off the train."

"Limped?" Aunt Heddie repeated. "She used to be able to walk so you could hardly notice. But I haven't seen her in fifteen years. Is her leg worse?"

"I guess it is," I said. "It gets stiff from bad circulation. Then she has a hard time walking on it at all."

Aunt Heddie blinked rapidly. "Joseph," she shrieked, "what if they won't let her cross the border? Or board the ship?"

"Don't worry, my pet, don't worry. They are strict, yes, but they also take bribes. Samuel can offer a very handsome bribe. And if not Samuel, then I will," he said. "Come, Perele, we are making you talk too much. You're the only one who hasn't finished the soup."

"I think I've had enough," I murmured, staring at the tablecloth. I had never even considered that Aunt Rachel might not be able to come. The thought lay in my stomach like a large rock, dragging at my whole body.

"Zivia, we have finished the soup," Aunt Heddie called. She shook her head and smoothed her sailor's blouse, which was just like mine. "The sooner happiness comes, the sooner it's snatched away," she announced. "I won't sleep tonight worrying about Rachel."

"Please, Heddie, it will be all right," Uncle Joseph soothed.

"Ah, stuffed *kishke* and candied carrots. My favorites."

Zivia went back and forth, bearing a parade of delights: roast chicken, calves' foot jelly, groats, poppyseed rolls, stewed plums. Aunt Heddie passed the serving plates.

"See, Perele," she boasted. "We even have a lettuce and tomato salad, with green peppers. In this country, they eat fresh vegetables every single night at dinner. They say it's very healthy."

"But we don't like it very much," piped up one of the younger boys.

"Eat, child, eat," murmured Old Mr. Edelman. "You have to grow big and strong like David."

David certainly was big and strong, and he didn't have to be urged to eat. He heaped his plate with huge portions of every dish that passed, and he was busy stuffing himself while his mother beamed at him.

"David, Perele has taken almost nothing. Here, put some of these carrots on her plate and give her a drumstick," Aunt Heddie ordered.

"I'm not really...."

"You have to keep up your strength," Uncle Joseph insisted. "Look at you, a skinny little thing. By the time Rachel and your father arrive, you should have a little meat on your bones. We don't want them to think we starved you!"

"Since Perele is going to be an American girl, she should have an American name," David said. His voice was muffled with all the food in his mouth. I could see drops of saliva land on the tablecloth.

"But 'Perele' is such a beautiful name," Old Mr. Edelman said. "It means 'little pearl.' It's the name her mother and father chose."

"But when she starts school the kids will make fun of her if she has a foreign name," David said. "I know. They used to make fun of my accent when I first started school, remember? I could hardly speak English."

"But Perele's English is coming along nicely," Aunt Heddie added. "She had a tutor in St. Petersburg, and she'll have one now."

"But 'Perele?'" David sneered. It sounded like a bad word when he said it.

"My *real* name is 'Perele,'" I put in. Nobody had bothered to ask me.

"Well I'm going to call her 'Pearl,'" David insisted.

"Me too, me too, Pearl, Pearl," the other boys chimed in.

A hot claw of resentment rose in my throat, but I said nothing. I looked at David as he sucked on a chicken bone beside me, grease dripping from his chin. We had always eaten with grace and dignity in Russia, and Aunt Rachel used to lead the conversation in gentle paths so that nothing painful ever disturbed our meals.

"Perele, Perele, you're not eating a thing!" Aunt Heddie complained.

"It's 'Pearl,' Mother," David insisted. "Call her 'Pearl.'"

"I don't feel very well," I said. "May I go up to my room now?"

"Yes, of course, darling," Uncle Joseph said. "You just got here. You should rest."

"But with nothing in her stomach?" Aunt Heddie snorted.

I left the table.

The days fell into a pattern. Aunt Heddie called Mrs. Tumaroff, who was an "elocution" teacher. I looked that up in a dictionary and discovered that "elocution" means the art of speaking. Mrs. Tumaroff, who had tightly waved blond hair that appeared gilded, taught me a lot more than that, though. At our first lesson, she explained that she would expect me to read one book a week in English, and write down twenty words that were new to me. Then I was to look them up, learn their meanings, and write out each word in a sentence.

When I protested that my English wasn't good enough to read a whole book, she simply smiled and said I'd be surprised how much I knew that I didn't even know I knew. She seemed so sure and optimistic that I thought maybe she was right.

Mrs. Tumaroff also gave me a book; a collection of poems named *Poems That Touch the Heart.* It had warm, sentimental poems like "Cloak of Laughter" and "Home Is Where There's

One to Love Us." She asked me to memorize one poem each week to recite during my lesson, and she would help with the pronunciation. This didn't worry me, as we had memorized a great deal in school in Russia, and I was used to it. In fact, when I started to work on the first poem, I found it had such a regular rhythm and rhyme that it was almost impossible to forget. The lines ran through my head over and over at night as I tried to fall asleep in my strange bed. They helped me stop thinking of Aunt Rachel and her dreadful limp.

After a few weeks I looked forward to Monday afternoons with Mrs. Tumaroff. She would set her leather briefcase by the door and stand very straight at one end of the long, gloomy living room. I faced her across the dark oriental carpet of maroon flowers. We would always start out by breathing deeply to see how tall I could stand: tummy in, shoulders back, head up. Then she would ask me to recite the poem I had memorized. I would say it as well as I could, trying hard to pronounce the W's correctly, and to remember how to say the H's.

"Open those Cupid's bow lips a little more," she would say, stretching her own crimson lips to show me. Or sometimes she said, "Slow down, slow down, you don't have to catch a train!"

We would go over and over a poem until I almost sounded like an American. Then I would give her my list of vocabulary words, and she would ask me to tell her what they meant from my own head.

Mrs. Tumaroff was beautiful. She looked like the women I saw in magazine advertisements, and I admired her. She was the first woman I had ever known who worked for money, besides the servants, of course. I wondered if I might be able to do something someday that people would pay for. I knew it wouldn't be teaching. I would never have the patience to go over and over every lesson the way she did, and still be cheerful.

Aunt Heddie enrolled me in piano lessons a few weeks later. On Wednesday mornings I had to walk to Mrs. Sugarman's apartment five blocks away. I loved the walk, for I felt I was really seeing America. Handsome carriages went by, as well as motor cars which were new then. Knife grinders rolled their great round stones along on little carts and called "Knives!

Knives! Scissors!" at each window they passed. Horse-drawn vegetable carts rattled by, and I practiced naming the vegetables I knew in English, and wondered about the ones I had never seen before.

Although I tried hard to please my piano teacher, I didn't have much of an ear for music. She usually had to tell me when I made a mistake. She was always surprised that I couldn't hear it myself. I did practice on the great, shiny grand piano in the mornings when the boys were in school, but I didn't make much progress. What I really liked abut the lessons was Mrs. Sugarman's cat, a friendly, flat-faced beauty with long gray fur named "Sooty." After a while I started to arrive early for my lessons so that I could chase the cat around the carpet while Mrs. Sugarman finished up with the student she had before me.

After six weeks of this, Mrs. Sugarman advised me to take the cat home with me and give up the lessons. "You'll never be a piano player," she announced. I carried the gentle Sooty home in my arms while she nestled and purred.

Aunt Heddie's lips turned down when she saw us.

"We don't live with animals in America!" she shrieked. "In the old country, in the villages, the peasants live with chickens and cows! We crossed an ocean so we don't have to live with animals!"

"She's a cat," I pointed out, "not a chicken or cow. And she has very good manners, don't you, Sooty?" I stroked the thick fur and nuzzled the cat's nose with my own. "And my teacher says I'll never be a piano player, so I might as well give up on lessons."

"The boys do so well with the piano! It's not enough to know Russian and Yiddish and English! You have to show you come from a good home! A cultured home! You want to be a good wife for...."

By that time I was halfway up the stairs with Sooty still nestled in my arms. If Aunt Heddie didn't want Sooty around the house, well then, the cat could live in my room.

When the boys noticed I would routinely take scraps of food upstairs after dinner, I told them I had a cat living with me. They begged and pleaded with their mother until Sooty had the

run of all three floors, and ate in the kitchen like a proper cat. Zivia did not like this at all, and could be heard scolding the cat in Russian while she prepared dinner. Sooty soon took a special liking to Old Mr. Edelman, who gave the cat secret belly rubs when he thought he was alone with her. I think he was afraid to show my aunt how much he loved the cat.

About this time I started to have a sort of social life. Dance halls were very popular gathering places for young people, with admission ten cents for gentlemen and five cents for ladies. Although these dance halls were filled with people that Aunt Heddie considered "common," she was so pleased that David and I actually wanted to go someplace together that she encouraged us. So David and I enrolled in dancing lessons at Bennie Bernstein's Dancing School at Second Street and Avenue B.

At the beginning of the evening, all the men would be seated on one side of the hall, and all the ladies on the other. Mr. Bernstein started things off by ringing a bell and announcing loudly, "Ladies and gents, when I give the signal, the gentlemen will cross over and ask the ladies to dance. No running, please." We danced to live music, provided by a band consisting of a piano player, a drummer, and two trumpets.

David never asked me to dance. From the way he acted, nobody would be able to tell that we were "betrothed." I had a hard time believing it myself. He had a very superior attitude toward me. He acted as if I were some kind of kid sister that he had to drag around but was happy to ignore as much as possible.

And I? I was not ready to admit it to myself yet, but I couldn't stand him. He was greedy, loud, bossy, and conceited. Worse yet, his family thought he was the greatest gift to humanity since somebody invented the wheel.

One of the benefits of these dancing lessons was that I met other girls my own age, all immigrants from Russia who loved the dance halls. Many of them, not as fortunate as I, were working in the garment industry to help support their families. Some of them didn't even have families, but had come to America as their best hope for a life of opportunity. I was fascinated by their stories of long hours of hard work, and by their inde-

pendence. Many of them weren't any older than I, but they were living on their own and had great dreams for the future. In a strange way, I envied these girls, for they were in charge of their own lives. At least it seemed that way.

And so for about eight weeks life flowed along smoothly. David liked to correct my speech to show how smart he was, and although it irritated me, I did learn from his constant picking. I also had an English tutor in addition to Mrs. Tumaroff, who worked with me on written exercises.

I missed my family and home in Russia. I would lick my tears as they flowed to my chin sometimes when a longing to see Aunt Rachel's kind face overcame me, but I looked forward to our reunion. I had written a letter to her the day after I arrived in America. Surely an answer would come any day!

When a letter finally came, with my own name spelled out above my New York address in Aunt Rachel's spidery writing, I raced upstairs to my bedroom and slammed the door. I wanted to read it without any interruptions. I tore open the envelope and unfolded the thin paper.

My Darling Niece.

I know that you are happy in my sister's house surrounded by people who love you. My heart tells me it is true. If you were miserable I would somehow sense it, even though the distance between us is great.

I'm afraid I have bad news for you. I have seen Dr. Stroganoff, whom we have had for so many years. He advises me strongly against emigration. My leg continues to atrophy, and now I must use a cane to get about. He warns that soon I will not be able to use the leg at all, but will have to rely on servants to help me around the house. Even if I manage to bribe the doctors at the German border into letting me cross, he says I would never gain admittance to America at Ellis Island, and that no amount of your father's money would buy my way in.

I still try to persuade your father to go to America without me. He no longer travels, since he sold his business for a pittance to a young man from Moscow.

Samuel was happy to find someone bright and capable to replace him, but now he mopes around the house like a very lost sheep. A new country—or any change—would do him good, but I can't talk to him about anything these days. The business was his heart and soul.

Meanwhile, my darling niece, when I am not being selfish and missing you, I rejoice in your good fortune. You will have a far better life in America than you would have had here. Heddie writes that David will go to law school in the fall. Isn't that wonderful? He would never be allowed to attend law school here!

I imagine your English must be quite fluent by now. Remember how we used to study together? Now, of course, there is no reason for me to pursue it, and I have given up working on my English.

Do you remember our old maid, Marya? We wept together for days after you left. Now she gives me all sorts of special little attentions, the way she used to give you. I'm afraid she feels sorry for the way I hobble about on my cane, but there is no need. My great joy is knowing you are well and happy.

With very special love,
Aunt Rachel

I felt a deep well of misery sucking me down, but I fought it as hard as I could. It wouldn't do any good to feel sorry for myself.

I knew what I had to do.

Chapter 5

"I'M GOING BACK to St. Petersburg," I announced at dinner that night. "Uncle Joseph, will you make arrangements for me?"

"She's upset," Heddie cautioned the table at large. "She doesn't know what she says."

"I'm not 'upset,' I am miserable. And I am going back as soon as I can."

"Will someone please explain what is going on here?" Uncle Joseph said. "I work hard all day, I come home, I want to enjoy my family in peace. Perele, why do you want to go back?"

"Call her *Pearl*," David muttered.

"Rachel can't come," Heddie wailed. Her voice was thick from the tears that had started when I read the letter to her. "Her doctor won't allow it, her leg won't allow it, she is a

cripple. And the leg is getting worse. Soon she won't be able to walk at all."

She wiped her eyes roughly with her napkin, and pushed away her plate. "Zivia! Take this away! I couldn't eat a thing."

Old Mr. Edelman shook his head. "Eat your dinner. You'll feel better."

"And what does Samuel have to say about all this?" Joseph asked.

"You know my brother." Heddie rolled her eyes toward heaven. "Only God knows what he thinks, and sometimes even He doesn't know. And now she wants to go back!"

"Of course that's impossible." Uncle Joseph said. "Perele— eh, Pearl—you came here to marry David. We have accepted you as our own daughter. Is there something you want that you don't have?"

"I want to go back. I want to see Aunt Rachel. I want to take care of her."

"I don't care if she does go back," David said. He helped himself to another poppyseed roll.

Aunt Heddie moaned.

Uncle Joseph swallowed a long draught of seltzer water and marshaled his arguments. "David, don't be crazy. You don't know what it's like there. There, they attack Jews for sport. Pearl, if you go back, you don't know if you'll ever be able to leave again."

"And besides," Aunt Heddie shrieked, "Rachel wants you to stay here! She said so right in her letter! Tell them, Perele."

"Is that true?" Old Mr. Edelman asked.

"I don't care what she said in the letter. You don't know her. You haven't seen her for fifteen years. She only said that because she thinks it would be good for me to stay. She would never ask anything for herself. I have to go back."

"Years ago, when you were a little fish swimming in your mother's belly, your grandfather held a family meeting," Uncle Joseph said. "We gathered around his *samovar*, and he never said a word until the maid had served hot tea to each of us. David was there, too, but he was only three years old."

David actually stopped eating for a moment to listen.

"He told us he wanted us all to emigrate to America, that they will never leave us alone in Russia, they will hound us for eternity. Heddie and I had already talked about emigrating, but we hated to leave the family. But when we heard that, we carried out your grandfather's wishes. Your father refused to leave, Perele. I think it was because your mother was carrying you, and he was worried about her health. And his business, of course. I had to leave my business, too. But when my own father said he would come with us, I knew it was the right thing to do. We thought about David, and how many choices he would have in America."

Uncle Joseph laughed bitterly.

"Your father said that since there was a new tsar on the throne, things might get better. Your grandfather answered him, 'The more things change, the more they stay the same.' He was right.

"And so, Little Pearl, I think you must stay here with us. It is only right that you carry out your grandfather's wishes, and your father's, and ours."

"Oh no," I said.

"How can you go back alone?" the youngest boy chirped. His eyes glistened with tears. "You are our sister."

"But Aunt Rachel was my mother," I said, as gently as I could.

"Then let's all go!" he said.

"The boy doesn't know what he says!" Aunt Heddie screamed.

"How is a man to eat?" Uncle Joseph muttered. He pushed his plate away, too.

"Perele, you don't read the papers, you don't know what's going on. There are protests everywhere against the tsar, and not just from Jewish people. There is talk of a revolution, a bloodbath that will shake Russia to the tiniest village and hamlet. Even if you were not promised to my first son, I would not let you go back. Put it out of your mind, Pearl."

Uncle Joseph resumed eating as if that were all there was to say on the subject. But I was used to having my way when I felt something was important; that was a gift from Aunt Rachel.

"So you're not going to buy a return ticket for me?" I demanded.

Uncle Joseph shook his head.

"Then I'll write to my father and ask him to send me the money," I announced.

"Good-bye!" sneered David.

Aunt Heddie sobbed hysterically. Zivia came running from the kitchen and helped her to her bedroom.

Once I had written the letter to my father and sent it off, I had a sense of well-being. When the money arrived, I would return to St. Petersburg and take care of Aunt Rachel for the rest of her life. I would show how much I loved her and how sorry I was that I had left. I knew my father's gloomy disposition, and I knew life must be dull and dreary for my dear aunt. Meanwhile, I felt free to enjoy the time I had left in America.

I still loved my elocution lessons and worked hard at my English. I thought I might come back to America someday, but I didn't think about it too hard. There was no need to decide anything now. As for David, he acted as indifferently to me as I felt toward him. I did suffer a twinge at the thought of leaving Sooty, the first house pet I had ever had in my life. But as I saw how she attached herself to Old Mr. Edelman, and how happy they were together, I decided that she would have a good home here without me. I would find another cat in St. Petersburg.

The rest of the family acted as if nothing had happened. Aunt Heddie continued to nag me about my English, my clothes, my posture, and anything else that came to her mind. Now that I knew I would not marry David anytime soon, and probably never, I felt more comfortable with him. I began to enjoy our twice-weekly outings to Bernstein's dancing classes.

One chilly January evening when we arrived at the dance hall I noticed a familiar face across the room. No, I thought, she is not one of the girls I met here at the dance hall. This girl was somehow from my past, from some other life. It was a very strange feeling. When I studied her animated gestures I felt a surge of affection. I started to cross the room towards her, and

suddenly—I knew. She was my cabin mate who had crossed the Atlantic with me on the *Kaiser Wilhelm*. We had promised we would always stay in touch. I stood quietly on the edge of her little circle for a few minutes, until her eyes met mine.

"Perele!" she cried. "Is that really you?"

I laughed and gave her a quick, happy hug. "Oh, yes, yes. Oh, I never thought I'd see you again."

Arm in arm, we strolled to the chairs that lined the walls. "But Frieda, I thought you were going to Boston! And you were going to marry a man there—didn't you tell me he had a grocery store?"

"Well, I was," she said. "It was really his father who had the grocery store, and Michael—my fiancé—was supposed to go in with him. His little brothers were still in Russia with his mother, who had refused to leave. But his father died, and Michael sold the store so he could go to school. He didn't want to have to slave twelve hours a day like his father, that's what he said. He decided to be a teacher. He wanted to finish school before we married. I came here to New York with the last of my money, because I couldn't find work in Boston. It's much easier to get a job here; I work in a shirtwaist factory and make seven dollars a week."

"How did you like Michael?" I asked.

"Oh, he's...it was a little hard to tell. He seemed stiff and sort of...sort of far away. But of course that was because he was shy with me, I'm sure. And I don't think boys talk as much as girls, do you?"

I thought of David, who never said anything that wasn't a criticism. "I guess not.

"But where do you live?" I asked. I couldn't imagine life without a network of family.

"I live in a boarding house. It's really just a very large flat where the landlady rents out rooms. I pay three dollars a week for the room, that includes dinner. But you have to tell me how it is with you. How do you like your new family?"

I told her all about them, and about my poor Aunt Rachel in St. Petersburg, and my plans to return. Frieda listened intently, her narrow, dark eyes flooding with sympathy. "Oh, Perele,"

she exclaimed, "how brave you are to cross that ocean again. I felt lucky to get here alive, and now you are going back!"

"Yes, but...."

We were interrupted by the ring of Mr. Bernstein's bell that signaled everyone to sit down. "And now, would the gentlemen please ask the ladies to dance?" he announced, when everyone was seated.

"We mustn't lose each other, Frieda," I whispered. "Maybe you can come visit me at my aunt's house. When are you free?"

"Only on Sundays," she said. "I work six days a week, and even on Sundays I have so much to do to repair and wash my clothes for the coming week. It's hard for me to get away."

"Well, maybe I could meet you one Sunday and we could walk in a park. I'll be here for a while before the money comes from Russia. Where do you live?"

"Oh, we could meet at Jackson Street Park after I'm through work one evening. It's dark by then, but there are lights in the park."

"Well, let's do it. Where can we meet?"

"There's a stone pavilion at one end, with a milk stand in front of it. Maybe you could meet me there on Wednesday night?"

"I'll find you," I promised.

I had never gone out by myself in the evening, and Aunt Heddie demanded an explanation. When I told her where I was going, she was horrified.

"Who is this girl Frieda? Nice girls don't go walking around the streets at night. You might be abducted, sold into white slavery. Yes, it happens. Who knows what she wants? She has nothing; no family, no money. Maybe she works for the white slavers. They take innocent young girls like you and sell them for men to use. For money. Why doesn't she come here, like a nice girl?"

"I told you. She works hard every day and doesn't have time to run all over the city."

"So you go out to Jackson Park? In summer it's so crowded families lie on the ground. It's not grass, either, it's asphalt, solid

asphalt. You see men there in their undershirts, not even a decent shirt to their name. Is that where you want to go? Do you forget you're the granddaughter of Avrom, button maker to the tsar?"

"I think Frieda's wonderful. She takes care of herself and doesn't have anybody like you to order her around."

"Like me?" Heddie's voice slid uphill to a shriek. "I took you in and treated you like my own daughter. This is what I get?" The tears flowed and sobs shook her shoulders. Zivia came on the run to help her to her room.

I snatched my coat from the hall closet and left. The smell of camphor that Zivia scattered to prevent moths followed me like a reproach as I ran down the steps. I had never spoken so rudely to anyone, and I felt guilty.

I hailed a cab and had time to think on the long drive. Aunt Rachel had told me that Heddie and my father did not get along with each other. My sympathy had been with Heddie before I met her. After all, I knew my father was a morose, silent man. He loved only his business and the sparkling gems he bought and sold. Aunt Rachel got on very well with my father, but she was such a gentle creature she could get on with an ogre if she had to.

Now I could see for myself that Aunt Heddie was selfish and bossy. A little shiver ran through my shoulders as I thought of her plans to make me her "daughter." Maybe I wouldn't return to America, after all. Maybe once I was back in St. Petersburg I would simply stay there. It seemed an easy way out.

I found Frieda quickly at Jackson Park that night. It was already the tenth of January, and our breaths rose in pale plumes as we chatted. I saw that Aunt Heddie was right, in a way. I saw worn, work-roughened faces and ragged, dirty children. I heard the babel of Yiddish and Russian and broken English and other languages I didn't even recognize. Trash and smashed bottles littered the park, and now and then a beggar approached with an outstretched hand. This was a different side of immigration than I had experienced.

Frieda was the first person I asked to call me Pearl. It seemed right, since she was my first friend in America.

"Pearl is my American name," I explained. "Although I'll probably never hear it again once I return to St. Petersburg."

"Oh, Pearl, I'm sorry you're going back now that I found you." She gave my arm a little squeeze.

"You must have lots of friends that you see at work," I comforted her. "My aunt didn't even let me go to school this year. I have tutors, same as in St. Petersburg. And in her letters, she was always bragging about how good the schools were. She says I'll be ready next year. I haven't met anyone but my cousins."

"I do have lots of friends," Frieda said. "Oh, I would love it if you could meet them! They work hard with their hands all day long, but they're not hard inside. They have dreams and ideas, and they read novels and newspapers and anything else they can find. There's even talk of banding together to change working conditions—or at least try. If we unify, we can strike all at once, and the owners will have to listen to us. Have you heard about this?"

"No, I never hear about anything. Aunt Heddie keeps me busy with my English lessons. I guess she's right about that—or she was, before I decided to go back."

"Are you still working on English?"

"Yes. It's coming along well. It won't be wasted. If I had the patience, I could be an English tutor in St. Petersburg. I wish you could see my elocution teacher, Mrs. Tumaroff. She's elegant. She speaks so beautifully that even Old Mr. Edelman likes to listen to her. And he doesn't know a word of English!"

Something brushed my cheek like a whisper. I held out my hand, encased in a black woolen glove. In a moment several tiny snowflakes, six-pointed like Jewish stars, decorated the palm.

"It's snowing!" I cried. "Our first American snow!"

Frieda grabbed my hand and we ran through the park with our mouths wide open to catch the flakes, until we collapsed onto a bench at the other end, gasping and giggling.

"You have stars in your hair," Frieda gasped, her chest heaving. "But they're melting fast!"

"I'd better go home," I said, when I had caught my breath. "My aunt didn't want me to come at all. When will I see you again?"

"I don't know. Sometimes I'm too tired to go to the dance hall. Let's meet here at the park again a week from tonight."

"Good, I'll see you then." I drew a piece of paper and a pencil from my coat pocket. "Why don't you write down your address, just in case I miss you. It was a miracle that we found each other at all!"

I rode home that night with a light heart, elated that now I had a friend in America. I resolved to write to her once I was back in Russia. I watched the light snow fall and trace the bare winter branches and thought how beautiful snow is, in St. Petersburg or in New York or anywhere in the whole world.

My mood lasted until I entered the front hall at the Edelmans' house. Before I even took off my coat, Aunt Heddie's familiar shriek accosted me. "It's about time you're home! You have a telegram from St. Petersburg."

I ran into the parlor, tore open the yellow envelope, and threw myself at Uncle Joseph's feet so that I might share his circle of lamplight.

STAY IN NEW YORK CONDITIONS HERE VERY BAD STOP YOU ARE LUCKY TO BE THERE STOP FATHER

Heddie took one glance at my stricken face.

"Aha!" she crowed. "Samuel isn't so eager to drag his daughter back to Russia, where anything can happen. And anything does! So, my pet, you will stay here and bring happiness to your new family. And you will marry David as it was agreed, and we will be proud of you. Take off your coat, Perele, it's hot in the house. You'll catch cold."

"No!" I screamed. I leaped to my feet and tore the telegram in two. "*No, no, no!* I won't marry David. No power on earth can make me. I don't *like* David!"

"Since when do you have to like him?" Uncle Joseph muttered, peering over his newspaper. "All we want you to do is marry him."

I dashed out of the room and raced upstairs to my bedroom. Aunt Heddie's wails pursued my every step.

Chapter 6

I LEAPED ONTO my bed and vented the rest of my grief and rage on the goosedown pillows. I tore at my quilt and screamed. When the storm finally passed, it looked as if a hurricane had swept through. But when I calmed down I realized everything had changed.

Soon I felt wild and giddy. My life was my own for the first time since I had arrived in America. No more trying to like David, or to pacify my demanding aunt. No more pretending to be someone I was not.

My father's curt message played over and over in my mind. Of course he would not have consulted Aunt Rachel, and even if he had, he would have paid no attention to her opinion. Also—and my mind stumbled over this thought as over a sharp rock—maybe Aunt Rachel really did want me to stay here. I ran away from the thought, found myself bruised, and circled back to it.

Nobody could stop me from doing what I absolutely wanted to do. I touched the cold, faceted surface of one of the diamond earrings. They had glittered in my ears since my first full day in America. My father knew the value of jewels better than he knew anything, and I was sure I could sell them for more than enough to buy passage back to Russia. But my independence would disappear with the diamond earrings. Once I sold them and spent the money, I would be once more at the mercy of everyone else's whims.

I pulled the down coverlet over my head. As I grew warm and sleepy old scenes drifted through my mind. I remembered my father's bloody, outraged face when he was stoned on the way home from the railway station. I remembered the downcast eyes of my Christian girlfriends after news of attacks on the Jews at Kishinev had spread through our city. And I saw Aunt Rachel's kind face, her hazel eyes glowing at me from her favorite chair. In my half-dream she was encircled by the lilacs on the chair's creamy fabric.

"Don't come back to this wretched country," she whispered. "Stay in America and make it your own."

And then, in that patient way she had always spoken to me, "What is it you really want, Perele?"

By then I was asleep.

Two days later, when the boys were at school and Aunt Heddie was at the hairdresser's having her auburn hair set, I left the house. I wrote a note saying that I was going to live with friends, and I could no longer stay in that house where they expected me to marry David. I told Aunt Heddie not to worry about me; I would write to my father and Aunt Rachel in St. Petersburg.

I took only my best trunk, filled with as much as I could stuff into it, including my new American clothes, and left the other trunks down in the cellar. I wore my beautiful green wool traveling cloak. I had hoped to escape unnoticed, but the "thump, thump" of my trunk down the stairs from my room brought Zivia running from the kitchen.

"I'm leaving," I said. I smiled to show that I was happy. After life in this stifling household, the thought of freedom had great charm.

"What will your aunt say?" demanded Zivia. She stepped out to block my way and folded her heavy arms across her breast. "You will destroy her life."

"I have a life, too."

She stood solid as a wall.

"Look, Zivia, I have money. Aunt Heddie has been generous. I have more money than most girls in the city make in five months. I have a friend, and I have my wits about me. Let me go."

She showed no signs of moving. I felt a flush rise from my throat and flood my cheeks. It was bad enough to be bullied by Aunt Heddie, but this was ridiculous.

"Zivia, get out of my way and go find a cab or I swear I will climb out the second story window some night when you are all asleep."

She stood like a castle of rock.

"And I will leave a note saying it is your fault!"

That did it. Shaking her head and muttering, she went out to find a cab. Eventually, after holding up a finger to indicate the driver was to wait, she came back to the front hall and picked up my trunk in those massive arms of hers. She threw it over one shoulder and marched out into the street. I swept down the stairs in my cape and stood regally at the curb while she hoisted my heavy trunk atop the horsedrawn carriage.

"Go with God," Zivia said. She held out her arms to hug me, thought the better of it, and marched back into the house. I handed Frieda's address to the driver, climbed into the cab, and was on my way in a clatter of hooves.

As we approached the "boarding house" where Frieda lived, I shivered. It was on Orchard Street, on the east side of the city. Shabby brick tenements lined both sides of the street, so tall they blocked the sun. Bushels of fruit and vegetables were heaped on the sidewalks in front of grocery stores. The rich, fermenting smell of overripe fruit mingled with the country aroma of horse manure. Rotting vegetables and dirty bits of paper littered the slush below the curb. The street itself was clogged with merchants' carts loaded with everything from rags to

luggage to pots and pans. The horse picked its way carefully through this confusion, while the driver squinted between carts looking for the right number. I peered into dim alleys. Pale children tossed balls back and forth beneath limp forests of laundry blowing on high window clotheslines.

Was this where Frieda lived?

The cab pulled up in front of a narrow doorway between two markets. The driver wrestled my trunk from the roof, then held out a hand to help me down. Ignoring his hand and the dismay that filled my heart, I jumped from the carriage and rummaged in my pocket for his money. He carried my trunk to the doorway, tipped his hat, and clip-clopped away.

I climbed creaky, smelly stairs to the third floor and wandered down a long corridor, holding up my cape so the hem would not sweep the dust and garbage that littered the floor. Finally, I found 37B and knocked.

The door opened a crack. A wrinkled crone with black hair growing from her nostrils squinted out at me.

I was sure I had made a mistake.

"Does Frieda Lewitz live here?"

Two bloodshot eyes studied me. "Are you a friend of hers?"

"Yes."

"She lives here. But she's not here. She works for Lehman Waist Company, sewing shirtwaists. All day." The eyes scrutinized me again, taking in my rich green cape, my fine leather shoes. "She's not as well off as some people."

"I want to rent a room. I'd like one next to hers, if I may."

"Everyone wants to rent a room," the crone muttered. She opened the door to the apartment so I could see down a long, dark hall. "But I don't have any rooms left, only a bed in the corner where the hall turns. It wouldn't be good enough for someone like you."

"Well...." I thought I would leave, but there was no place to go. In an instant I decided I would rather die than return to Aunt Heddie's house.

"Well, maybe I could stay in the hall until you have an empty room. Or until I find someplace else."

"There's a little matter of money," the crone pointed out.

"For the hall I'll only charge a dollar and a half a week. That includes dinner; I serve every night at seven in the dining room. Not fancy, but filling."

"I'll take it." I held out the money.

"Thank you. I'm Mrs. Bloom. The toilet's down the hall there, and the bath is on the third floor. We share it with two other floors. It's not bad, just remember to wash it out before you use it. Some of the tenants never do. And we get hot water from seven to ten at night."

"Oh, I left my trunk downstairs. It's right at the front door where the driver set it."

"I'll help you carry it up, dear," Mrs. Bloom offered. She drew a key from her apron pocket and locked the apartment door behind her.

She clumped behind me as I skipped down the two narrow flights of stairs. I threw open the heavy door to the street, and looked around wildly.

"My trunk is gone! Somebody stole it!"

Mrs. Bloom shook her head. "I'm afraid the neighborhood is going straight to hell," she sighed.

Frieda wept when she found me sitting at the dining room table that night. I was still dressed in my traveling outfit, trying to remain calm in the din of Yiddish and Russian and English that was spoken—or shouted—at the table. She dried her eyes and we nibbled as much as we could of our tough boiled brisket. We left the table before the coffee was ready.

We went to her tiny room and sat cross-legged on the bed. I looked out her window at the solid brick wall of the next building only a few feet away, and wondered if it looked like this from a prison cell.

"Oh, you're so brave, Pearl!" she squealed. "I never would have the courage to say 'no' to an arranged marriage!"

"You had the courage to come to New York by yourself. And you found a job," I said. "I was welcomed by a family committee."

"You must work with me!" she said. "Come to the factory tomorrow and I'll introduce you to my supervisor. He's a mean

old goat, but if you do your work and show up on time, he'll leave you alone."

"What exactly do you do?"

"I sit at a machine all day and sew shirtwaists. The pieces are all cut out when we get them. The cutters take care of that. We have electric machines; they only came in a year ago. But you have to be careful with the needles, because if you break one you have to pay for it. You also have to pay for a locker to keep your coat and lunch in. The lofts are so crowded there's no other place to put them."

"It's a wonder you're left with any money at all," I said. "Is there anything else they make you pay for?"

"Yes." She shrugged. "We have to pay a tax for the chairs we sit in."

Women's shirtwaists were the rage that year. A shirtwaist is a tailored blouse, with wide sleeves gathered at the shoulders and buttoned at the wrist. Most were embellished with tucks, lace, buttons, beads, embroidery, ribbons—anything that a designer could dream up. The collars of these "waists" were often high on the neck, sometimes with a bow, and always buttoned to the throat. They were made in every conceivable fabric, both rough and elegant.

Most newcomers to the industry were put to work on shirt-waists, since this job could be mastered in less than a week. All the sewing I had done on Aunt Rachel's Swedish sewing machine turned out to be a good start for a seamstress. My fingers guided the fabrics over the needleplate as if I had been doing this all my life.

I started out at three dollars a week, but learned so fast that I was soon earning five. It was a good thing. My cloak and my diamond earrings hadn't been stolen because I was wearing them, but most of my money had to go for a few clothes to wear to work every day, and some soap and other toiletries. Mrs. Bloom let me borrow a sheet, but I bought a warm night-gown and a blanket for my hall bedroom. It was a passageway for the other roomers when they got up at night to use the toilet outside the apartment. It was a dreadful arrangement.

I got up in the dark every morning. Since I had no privacy I dressed under the covers, then waited in line at the big sink down the hall for a chance to wash. Men, women, and children stood in line, the men in their undershirts, the women in dirty wrappers, the children still in their nightclothes, sometimes reeking of urine.

Frieda and I walked to the factory together, stopping on the way at a bakery for a glass of milk and a roll. Then hours bent over the sewing machines in a poorly lit, filthy loft. The toilet was in a tiny closet at one end of the loft. Often it was not working, and was seldom cleaned even when it did work. I learned to hold my breath when I used it; otherwise I would have gagged from the stench.

The loft windows looked out on the walls of other buildings. Many days it was impossible to tell if the sun was shining. Sometimes one of the girls would notice a drift of white flakes and the word would go up and down the rows, but we could not rush to the window to see. Mr. Schultz, the boss, did not allow us to spend time looking out the window.

My Russian boots had disappeared with the trunk. The elegant goatskin shoes Aunt Heddie had bought me were soon scuffed and water-stained, but I didn't want to spend money on new boots. Mrs. Bloom had promised me the next vacant room she had, and I was trying to save money for it. For the first time in my life, I knew what it was to be poor and miserable. I was hungry and cold and tired most of the time.

The only thing that kept me going was the work itself. I learned so fast that Mr. Schultz put me to sewing piping and lace trim, and raised my wages again to seven dollars a week. I had a steady hand and a keen eye for detail, and loved the bright mosaic of fabrics and trim that rose in little hills about us as the hours crept by.

Every day at noon we stopped our machines for twenty minutes and ate whatever we had brought with us for lunch. Some of the girls lived at home with their families. They brought the best lunches: a bit of leftover chicken or boiled potato packed by their mothers or grandmothers. Sometimes one of the girls had a bit of *kugel* of such a lovely golden color

that it almost brought tears to my eyes. We all loved fruit, but it was hard to find and terribly expensive in the winter. One of the girls brought an orange one day, and we all sniffed the delicious fruity aroma and thought that was almost as good as eating it. Frieda and I usually brought slices of bread and butter wrapped in napkins, left over from Mrs. Bloom's dinner the night before.

For weeks and weeks I was so tired from working that I simply went to sleep directly after dinner. The other boarders could walk back and forth past my bed as much as they would; I never heard a thing. But as the weeks passed, I grew used to the dreary routine and my back stopped aching from bending over the sewing machine all day. Then the slightest noise would wake me, and I would lie trembling, filled with vague yearnings.

I could not help comparing my life with the life I had led as a child, filled with beauty and luxury. Yet I wasn't sure I yearned to return to that life. I wanted something new, something better, something of my own making. I was consumed with longing for joys beyond my reach and shuddered with the ache of unvoiced dreams. I didn't even know what I might dream of in this strange land.

One evening I begged a piece of paper and an envelope from Mrs. Bloom. When I asked what the date was, I couldn't believe it was already March 16. Over two months had passed since I left the Edelmans' house, and I had hardly noticed the passage of time.

I sat at the dining table after everyone had finished eating and wrote a letter to Aunt Rachel. I told her everything that had happened, but I dressed up the facts in pretty colors. Cousin David was impossible, I wrote, bossy and selfish. Under my wicked pen, the hall bedroom with a few folded clothes turned into a bright, airy chamber with a sparkling bathroom. The roominghouse was right next to a lovely park with a lake, I told her, where Frieda and I liked to stroll under the trees and take the air after work every evening. Our supervisor at the factory had nothing but the welfare of his employees at heart and was deeply interested in our comfort.

Aunt Rachel hated lies. I felt a twinge when I dropped the letter into a mailbox the next day, but I knew the truth would break her heart.

Chapter 7

ONE OF MY pleasures was getting to know some of the other girls who worked with us. During our short lunches we were more interested in talking than eating, since the clatter of machines ruled out any conversation while we worked.

We complained a lot about working conditions, but when we heard the clumsy tread of Mr. Schultz, our supervisor, we quickly changed the subject. One very bold girl, Clara Lemlich, belonged to the International Ladies Garment Workers Union. She spent every moment that she was not working trying to persuade the rest of us to pay ten cents a week dues to join the union. Unused to working, or feeling any solidarity with workers, I did not join.

One day Frieda and I arrived at the factory in the morning dusk to find a bulb had burned out above her sewing machine. She waited for Mr. Schultz to show up before she started to sew.

"I'll have the light fixed when I have time," he barked. "Better get to work right away if you don't want your pay docked an hour."

And so poor Frieda bent her patient back over the work. By eleven o'clock, when we all felt a little shaky for want of food, a sharp scream brought all the machines to a sudden silence. There sat Frieda, weeping, her index finger dripping blood from the needle she had run through it. The shirtwaist she was sewing soaked up the blood in a crimson circle that grew larger and larger.

"That will cost you two dollars for the shirtwaist," Mr. Schultz shouted. "And do something about that finger right now! Do you want to stain some more?"

One of the girls tore a gray strip from her petticoat and bound up Frieda's finger, while I patted her shoulder and wiped away her tears with my sleeve. Subdued, Frieda went back to work in the dim light. When lunchtime came, a girl who lived at home gave her a slice of noodle *kugel* from her own lunch. I ran downstairs and bought her a glass of milk from the dairy bar across the street.

But when Frieda and I stopped for our breakfast at the bakery next morning, I noticed a thin red line, like a mark of doom, under the skin on the inside of Frieda's arm. The line ran up her wrist and disappeared under her sleeve.

"We can't go to work, Frieda. We have to find a doctor."

"How can I afford a doctor?" she wailed. "I don't even know how I'm going to come up with two dollars for the shirtwaist I ruined!"

"Frieda, your finger is infected. It's poisoning your whole system. You could die from it."

"Stop it, Pearl. You're scaring me."

"I'm trying to scare you. I've seen this before. One of our gardener's boys cut his finger on a nail back in St. Petersburg. The same thing happened. Aunt Rachel told me that if she hadn't fetched a doctor quickly, the little fellow might have died. The doctor gave us something to swab his wound with that took care of the infection. Also you need some medicine to drink."

"Pearl, if I go to a doctor I won't be able to pay the rent next week, never mind the cost of the shirtwaist I ruined."

"I'll pay, you goose. Do you think I'm going to stand around and watch you die?"

I held the bakery door open to the wind and started back to Orchard Street. Mrs. Bloom would know where to find a doctor. Frieda was so busy arguing that she scuffled along where I led without thinking.

"But you make seven dollars a week too. How can you pay for it?"

"Because I only pay two dollars a week for the privilege of sleeping in the hall. I started at a dollar and a half, but Mrs. Bloom raised it. That leaves five dollars a week, and I've been saving some. I want to move into a real room as soon as Mrs. Bloom has one empty. Come on, Frieda, or you'll die in the street, and I swear I'll leave you lying here!"

We found Mrs. Bloom in her cramped kitchen, but she took one look at Frieda's arm and started to scream. "*Gott in Himmel*," she cried. "You know what that is? That's what comes of it! Girls working like slaves!" She dropped clumsily to her knees and fished behind the dirty rag hung below the sink to hide the unlabeled bottles and jars she kept there.

"All I want is how to find a doctor," I said to her back. "Frieda...."

But when I looked at Frieda my stomach cramped with fear. Her face was flushed and her eyelids drooped. She looked as if she were ready to fall asleep on her feet just as she stood.

"A doctor! You think you're back in St. Petersburg? What kind of doctor will treat park pigeons like you? You think I've never seen blood poisoning before?"

Mrs. Bloom emitted a long groan and tried to heave herself to her feet, but she failed twice. It was not until I helped her up by grasping her elbows and pulling that she finally stood again. Both hands clasped cloudy bottles; one was faintly pinkish gray and one was filled with a transparent liquid. She pushed the transparent one at me.

"This is carbolic acid," she announced. "Don't let Frieda drink it! Keep it away from her face! Take a clean cloth—your undies if it's all you have—and soak it with the acid. Swab the hole on her finger with it over and over. Some people say swab

the vein, too. I can't see what that does. Put her to bed after she swallows a tiny glass of this...." Here Mrs. Bloom thrust the other bottle toward me. "And when she wakes up, give her another glass of it."

She spread her hand on Frieda's forehead.

"I knew it! Burning up with fever. Take a towel—here, take this dishtowel—and fill a bucket with cool water to wash her in. It'll keep the fever down. And fresh water to drink! Lots of water!

"Hurry up! Don't stand there like a ninny! Get her to bed! Don't you know she might...."

But I was gone with the two bottles under my arm and the dishtowel draped over my shoulder, dragging Frieda by one hand down the hall to her room. I stayed up with her all night, swabbing her finger and arm with the acid, dosing her with the quinine, and washing her burning body with cool water from a bucket.

The night passed slowly, but I had no trouble keeping awake. I knew the Angel of Death was nearby, and if I closed my eyes for even a few minutes it would snatch Frieda's soul. When the dawn glow seeped into the black room it found Frieda sleeping quietly, her forehead cool and the red line on her arm almost faded.

I went to work that morning with a headache, and had to endure Mr. Schultz's outraged scolding. He docked each of us a day's pay for yesterday, and Frieda another for missing today. I returned to my machine quietly, but inside I boiled. Frieda had wounded herself in the first place because of the burned-out light bulb. Surely the factory should have paid her wages.

The next time Clara came around to try to get us to join the union, I told her the whole story.

"Yes, yes," she said, bobbing her head until her braids swung. "That's one of the things we're fighting for, medical benefits. Nobody will give it to us if we don't fight for it!"

And so I joined the International Ladies Garment Workers Union, and persuaded some of the other girls to join. I made good friends that winter, and when the daylight hours grew longer we gathered after work in parks and candy stores.

Occasionally we met after dinner and went to a nearby dance hall, but I avoided going back to Bernstein's dancing classes. I was afraid that I might run into my cousin David. Some of the dances were given by the YMHA, the Young Men's Hebrew Association, on Broom Street. Days in advance, members of the "Y" would put up posters on street lamps and storefronts to announce these gatherings, which were called "balls." For ten cents we could buy an hour or two of dancing, until our weariness sent us home.

By midsummer Frieda and I knew many of the boys who attended these events, and we looked forward to seeing them. One of them, Morris, hardly a boy, must have been about twenty-five years old. He was the first to ask me out on the dance floor every time we went to the "Y." One evening Morris asked if I'd like to leave and walk to the park for a breath of fresh air. With Aunt Heddie's warnings ringing in my ears, I told him I would go if Frieda could come with us.

And so we strolled, Frieda and I on either side of this slender, wiry man. He took a grave interest in every thing we told him about ourselves. Morris was from Kiev, but he had been in America for almost seven years and had a good job as a pattern maker. He lived with his parents and sisters, who were prosperous enough to have a large apartment and rented only one room to a boarder.

When the weather was rainy, or when I was simply too tired to attend the "Y," Morris would always be waiting for me at the next dance. He would inquire about my health, about how I was doing at work, and about my living conditions. He had large hands that were warm on my waist when we danced, and a serious air about him that won my trust.

In July, one of Mrs. Bloom's boarders married and moved away, and Mrs. Bloom let me rent the tiny room. It was heavenly after three and a half months of living in the open hallway where the other boarders wandered through. The room had a narrow closet to hang my few shabby clothes in, and a window that looked out over the street instead of another wall. The days were so long now that I awoke each morning to pearly light flooding in the window, and I rose with high spirits.

That feeling didn't last long; only just as long as it took me to arrive at the factory. There, the constant clatter of machines, the heat, the smells, and the harsh temper of Mr. Schultz all caused me to grit my teeth and work as hard as I could. That way the days passed quickly.

I thought a lot about Aunt Rachel, the only person who had ever given me a mother's kind, unselfish love. I looked for a letter from her every evening when I returned to the apartment for dinner, but as weeks went by with no word, I grew anxious.

One hot summer evening I came back to my room and saw a white envelope that Mrs. Bloom must have slipped under the door. I spun in, scooped it up in one grand swoop, and...and it was not Aunt Rachel's writing. It was my father's.

Perele, it began, and I could hear my father's sternest tone, as if he were speaking. I dropped onto my lumpy bed and prayed for strength.

> I write to tell you that my dear sister Rachel passed away from a stroke a month ago. She was somewhat reassured of your welfare from your last letter.
>
> However, your fairytale did nothing to ease the pain and disappointment we felt when we read Heddie's letter, which had already arrived. Such ingratitude is not suitable to your gentle upbringing and good education. Heddie, of course, is willing to forgive you and accept you as a member of her family once again. But in addition to the wound you have inflicted on the Edelman family, you have done yourself a great harm.
>
> A woman alone, with no family to protect her, not a wife and not a mother, has no existence. That is the way it has always been, and that is the way it will always be. Therefore, I must inform you that from the day of my sister Rachel's death, I have had no daughter.
>
> I would have tried to accept your actions for Rachel's sake, as she was unaccountably fond of you. I am relieved there is no longer any need for such a charade.
>
> Sincerely,
> Samuel Sokolov

A groan cut me in two as the letter dropped to the floor.

The summer passed in a daze of heat, humidity, and sorrow. I worked harder than ever at the factory, concentrating all my energies on the fabric that flew between my fingers into the greedy maw of the sewing machine. But no matter how hard I worked, I still thought of Aunt Rachel every day.

Mr. Schultz noticed my zeal. He asked me to switch to sewing ladies lingerie: vests, slips, and panties. It was much finer, more demanding work, he said, and only the best seamstresses could do it. He raised my salary to ten dollars a week. Although I was still poor, I did not have to worry about money; ten dollars a week was enough to take care of my small needs.

I stopped going to dances at the "Y" with the other girls, since I couldn't bear their chatter anymore. All I wanted to talk about was Aunt Rachel, but I knew it would only make them melancholy. I began to roam about New York by myself, exploring further and further beyond the East Side. I discovered Coney Island, the Bronx Zoo, and the Metropolitan Museum of Art. Sometimes I would become so wrapped up in the paintings at the museum that I would forget my sorrow for an hour or two, only to remember that I was a homeless wanderer when I returned to my room after dark.

My only real contact that summer was Frieda, with whom I still walked to work every morning. On one of those mornings, while we were munching our rolls at the bakery, Frieda giggled and said she had a message for me.

"You can't have a message for me," I said. "I don't know anyone but you and Mrs. Bloom and Mr. Schultz, and I see them every day. And I see all the girls every day, too."

"Oh, yes I do!" she squealed. "Remember Morris?"

"Morris?" For a moment my mind was blank. "Oh, Morris. Morris who wanted to dance every dance with me. *That* Morris?"

"Yes, silly. *That* Morris, as if you didn't know. He's been asking for you. He wants to know why you don't come to the 'Y' anymore."

"Is that the message?"

"Not quite. He wants to know if you'll go walking in the park with him one evening, maybe next week. It's the first week of September. He says the long evenings won't last forever."

"Tell him the second week in September," I said.

Neither he nor Frieda knew it, but my birthday was the second week in September. I would be sixteen years old, and I no longer existed for my father. Maybe I existed for someone else, or maybe I didn't exist at all.

"You're going to make him wait that long?" she asked.

"What's the matter, are you worried about him?"

"No, Pearl, I'm worried about you. You never go places with the rest of us anymore, and we have a lot of fun. You don't even look well. You act like a ghost since your aunt died. You can't grieve forever. My mother always said, 'Life is for the living.'"

"Frieda, I feel so guilty. I should have gone back to Russia immediately, as soon as I left Heddie's house. It would have meant so much to Aunt Rachel to see me once more. It's eating at me."

"But how could you go back?" Frieda asked, her brow furrowed. I put out an arm to keep her from walking out in front of a motorcar, which we saw on the streets more and more often. "You had no money."

I smiled bitterly. "Want to know a secret?"

"If you want to tell me."

"Did you ever notice these earrings I wear every day?"

"Of course. They're beautiful. I've never seen glass glitter with so many colors."

"They're not glass, Frieda. They're real diamonds. My father is a jeweler, and he gave them to me. He said they are very valuable. I could have sold them for a lot of money and bought passage to Russia. But I didn't."

Frieda stopped stock still, there in the middle of the sidewalk, and threw her arms around me. "Oh, Pearl, I knew there was something bothering you. Besides your Aunt Rachel's death, I mean. Don't blame yourself for everything. It takes time to sell things, and then to book passage. You might have

been too late. Or your ship might have gotten stuck in some country.... I read in the newspaper that happens. Stop feeling everything is your fault."

"I'm good at it," I mumbled.

It would be a while before I felt what she was saying, but just telling her my guilt made it lighter.

"And you're crazy, really crazy, to wear those diamond earrings every day! What if someone steals them?"

I giggled and scuffled along the dirty sidewalk. The stitching that held the sole of my shoe was loose and it was almost coming apart. "Frieda, look at me. Do you really think anyone would guess these were real diamonds?"

She did look at me, up and down, thoughtfully, and met my eyes finally. "You look great to me," she said. "Maybe a little too thin."

"Oh, dear Frieda," I said, and took her arm.

The day of my birthday I went to work as usual. Frieda lingered after work, chatting and laughing with the other girls, but I dashed back to my room on Orchard Street as fast as my legs would carry me in the heat and humidity. I had learned they call such late heat "Indian Summer" here in America. I filled a basin at the tap down the hall and gave myself a quick sponge bath. Then I slipped on a fresh shirtwaist and a long cotton skirt, and glanced in the mirror that hung in Mrs. Bloom's dining room. I was so flushed there was no need to pinch my cheeks for color.

I met Morris at a candy store nearby. I was surprised how pleased I was to see his dark, narrow face. His shining black eyes stared solemnly into mine.

"You're different, Pearl."

I felt glad he had noticed. I was no longer the merry girl he knew; sorrow had provided a new seriousness to my character. And today I was sixteen, but I felt I had lived an eon in the last year.

We took a cab to the park at Williamsburg Bridge. A fresh, sweet breeze blew in from the river. We strolled along the paths among elegantly dressed ladies and street urchins in dirty night-shirts, among bearded Jews in long, black coats and clean-

shaven men in business suits. Everywhere, we heard the international babble of many languages.

I told Morris about my aunt's death, and how my father had decided that I no longer existed. He listened carefully and took my hand.

"So little, and so alone," he said.

"But I am doing very well," I protested.

I rested in his sympathy, but I resented it at the same time.

"My wages were raised twice at work, and I have a room of my own now. Best of all, I'm still in the same apartment as Frieda, and the landlady is kind."

I leaped out of the way suddenly as two boys playing kickball on the grass sent their ball careening toward me. Morris swooped and picked up the ball. One of the boys approached with his hands outspread, waiting for Morris to throw it.

"Not so fast, kid," Morris shouted. "What do you do when you almost hit a lady?"

The flushed and sweaty boy glowered, looked at me, then lowered his eyes.

"Sorry, miss," he mumbled.

Morris tossed the ball back. I tucked my hand proudly into the crook of his arm as we walked on. After all, here was a man who knew how to look after a girl.

Was that what I wanted?

We came to a bench that people were leaving. Morris grabbed it and we sat quietly for a half-hour or so, watching the fading light turn the river to a ribbon of silver.

Finally he cleared his throat. He glanced at me out of the corners of his eyes, and tried to smile.

"Pearl, I'm no longer a boy."

I stared at the sky. Did he guess it was my birthday?

"I'm tired of living with my family and sharing the apartment with my parents and sisters. On top of that, we have a boarder. I earn a good living making patterns. The garment industry is one of the most robust in the country. I've been thinking of getting married."

Oh, no! I thought. Not another betrothal!

"Pearl." He put his arm around my shoulders. "I am asking you to marry me."

I looked up at him. There was such a solemn pleading in his deep eyes, and such earnestness in his voice, that I could not bear to say no and hurt his feelings.

"We've only spent a few evenings together at the 'Y,'" I protested. "How do we know we'll like each other?"

"I like you already. Even more than that. And how can you ask such a question? My mother and father saw each other for the first time the day they appeared under the wedding canopy. That's the way our people have done things for ages, little Pearl."

"That was my name in St. Petersburg," I said, softly. "Perele, Little Pearl."

He leaned one elbow on his knee and sank his chin in his hand. "I know this isn't the way it's done, Pearl. I know that without a marriage broker I should ask your father. But if your father refuses to recognize you, what good is it? Besides, we are in a new country and we should do things in a new way."

I smiled at him. "Do you remember I told you once, when we were dancing, that I came to New York to marry my cousin David? And after I knew him, I hated the thought of spending my life with him?"

"I remember. But I'm not David. Give me a chance, Pearl. Think about it. We could get a little apartment of our own. Maybe we could buy a sewing machine, and you could sew at home instead of going to the sweatshop every day."

"Oh, yes, and who would I sew for?" I asked. "If we're ten minutes late, Mr. Schultz rages and threatens to cut our wages. I can just see him letting me stay home and sew."

"But you're talented. Frieda tells me even Mr. Schultz likes your work, and he's hard to please. You could sew orders directly for private customers. Custom work, one of a kind. Don't forget I'm a pattern maker, and I could help you."

"I have a secret to tell you," I whispered.

He bent his head close.

"Today I'm sixteen. This is my first American birthday and I'm glad I spent it with you."

"Does that mean you will marry me?"

"No. That means I'm getting cold and we have to go home. There's a breeze rising off the river. Look at the sun!"

For a few moments we watched the tiniest fleck of red sun drop into the silver river.

"Does that mean you won't marry me?"

"Oh, I don't know. I have to go back." I shivered a tiny bit, and he put his jacket around me.

Chapter 8

"PEARL! PEARL! Are you awake in there?" Three sharp raps on my door punctuated Frieda's voice.

"Stop shouting and come in," I called, placing a scrap of paper to mark my place in my book. "You'll wake up the baby who lives in..."

She threw open the door and danced in. "Guess what?"

"Well, judging by the paper you're waving around, I guess you got a letter. Is it from that long lost fiancé of yours? How nice he finally decided to write."

"Oh, Pearl, he not only wrote! Michael's coming here; I'll see him. This is New York! He has an assignment to visit the stock exchange and see how it works. He has to write a paper on it."

"Stock exchange? I thought Michael was studying to be a teacher. What is he going to teach, how to make money? He could teach me a few things."

"No. He changed his mind and his classes. He decided he wants to be a stockbroker, and get paid for managing other people's money. He's studying economics. Doesn't that sound great? It's about business. Can you imagine? In Russia, if you wanted to open a business, you opened a business, you didn't study for it. What a country this is!"

"When does the great man arrive?" I asked. "Or didn't you read that far?"

"Of course I did. He'll be here the last week of October. He wants to know if Mrs. Bloom has any extra space for him to stay. I don't know what to do. We're crowded like chickens in a coop here."

"Maybe he'd like my old bed in the hallway," I suggested. "After all, I put up with it for much longer than a week. Nobody else is in it, and it doesn't cost much."

"Oh, what an idea! I'll go ask Mrs. Bloom right this second!" She leaped off the bed and was gone, slamming the door behind her.

I went to my little window and stared down at the street. The greengrocers were gathering their produce inside their shops, preparing to close. *Babushkas*, old grandmothers, were still snatching pears and apples off the stands and haggling over the price. At this time of day they expected a discount because the fruit was no longer perfectly fresh.

The street was filled with boys on bicycles dressed in caps and jackets against the autumn chill, as well as peddlers wheeling their carts home, horsedrawn cabs rattling along on high wheels, shiny new motorcars, policemen mounted on chestnut horses, and children playing in the gutters.

Soon winter would come. I shuddered. What if Michael were to ask Frieda to marry him now and return with him to Boston? I drew my shawl close about my shoulders. I've lost other people and survived it. I'll find another friend. I turned from the window, sucked in a harsh breath, and fell across the bed sobbing.

Mrs. Bloom was like a housemother to her varied clan of boarders. Despite her warts and sparse hair, her bad teeth and

bad breath, she had a good heart. She agreed to let Michael have the hall bed for a week, although she really didn't like short-term boarders.

After that was settled, I cornered her in the kitchen one evening after dinner and asked if I could help her clean up. She sent me down the hall to the communal sink, where I filled a great bucket with warm water and lugged it back to her tiny kitchen.

"Whew!" I set the tub down. "How do you manage that every night?"

"You have to be strong in this life, dear," she answered, her arms up to the elbows in water. She clunked the dishes against each other so hard I thought they might break.

"And what is this girl up to, helping an old grandmother in the kitchen when she could be out having fun?"

"Fun is for kids," I said. "I want to know if anyone has a sewing machine I can borrow. Maybe one of the boarders, or one of your friends?"

"A sewing machine! I should think you'd get enough sewing at work, without cluttering up my little rooms. What do you plan to do with a sewing machine?"

"It's for Frieda. You know her Michael is coming and she hasn't had a new outfit in years—at least since I've known her, and that's a whole year already. I met her on the *Kaiser Wilhelm* coming over, did you know that?"

"No, but I could see you are very devoted to her. What does she want to do, make a new dress for herself?"

"No, I want to make a shirtwaist and skirt for her. I'm a better seamstress than she is, and I make more money. All I'll have to pay for is the fabric; there are plenty of buttons and trims at work that end up in the trash every day. I could take some of those."

"What kind of fabric would you buy? Something to set off her black hair and white skin?"

"I've been thinking of a deep rose shirtwaist, with braid trim at the neck and shoulders, and long, gathered sleeves. Maybe in cotton sateen if I can afford it. And a forest green wool skirt that would match the braid. What do you think?"

"I think it sounds lovely, Pearl. You're a good friend."

"Yes, but I don't have a sewing machine."

"I have one. It's not the electric kind you use at the lofts these days. It's a treadle, but it still works well enough to sew up a devil inside a man. You won't have any trouble with it."

"Oh, Mrs. Bloom, you are a dear!" I would have thrown my arms about her, but she was still sloshing around in soapy water.

"Not so fast, not so fast," she muttered into the steam. "First, grab that bucket from beneath the table and go get me some rinse water."

"And then? And then?" I prompted, my arms around the bucket.

"And then promise me you'll keep the whole mess in your room. With the door closed. If any of the other boarders see it, they'll get ideas. Pretty soon the whole apartment will look like one of those sweatshops."

"I promise, I promise," I sang. I skipped down the hall with the bucket, almost knocking down Mr. Radowicz, who was just then emerging from his room.

"Already we need street signs in here," he muttered, pressing himself flat against the wall. "These young people! Always rushing, rushing."

And he was right, I was rushing, although the bucket, once filled, was so heavy that I could hardly lug it back. I set it on the floor and pulled it down the long hallway.

I set the old sewing machine in my room in front of my window. I had to run out on my twenty-minute lunch break to shop for fabric, since that was the only time I could spare, but I managed to find the loveliest shade of deep rose for the waist, and some fine, light wool for the skirt.

I lured Frieda to my room one evening, and showed her the sewing machine set up with a chair I had borrowed from the dining room. When she saw the fabric she started to cry.

"Nobody has ever done anything like this for me," she wept. "Oh, Pearl, you are so dear."

"And you are the sister I never had," I said. "Promise we'll always love each other, dear Frieda. I have no family now."

We had a good cry together, thinking of how lonely and bare our lives were, and finally wiped away our tears feeling much refreshed. There were so few outlets for emotion in that hard life!

I set about taking measurements while Frieda stood and turned to my instructions. I laid out the fabric on the floor, the largest space I could find, and cut it with a pair of good, sharp, scissors that Morris had lent me.

My fingers flew in time to the beat of my heart. For the first time in New York, I was sewing something because I wanted to, something I had designed and planned. My spirits soared as the fabric flew beneath my fingers. Little by little, over the period of a week, the shirtwaist and skirt became whole. I thought about them all day at work while I sewed endless mounds of lingerie, and even dreamed of them at night.

There was so little light left when I got back to my room on Orchard Street that I sewed even during dinner until the twilight prevented further work. The gas light in the room was simply not strong enough to see by. Yet Mrs. Bloom always kept some food aside for me, and I rinsed my own dishes in the hall sink if she had finished washing up.

When the outfit was complete, Frieda came to my room for a final fitting. The sleeves, gathered at the shoulders, hung in lovely soft folds to her wrists. Braid trimmed the mandarin collar that gave Frieda the decorated appearance of an oriental princess. The green skirt encircled her narrow waist and fell in smooth lines to the hem, which was also embellished with braid. With a bit of leftover rose cloth from the shirtwaist I had made a wide ribbon that I tied around her dark curls. She looked truly beautiful.

I ran to the kitchen to fetch Mrs. Bloom to come see. Frieda stood glowing in front of the bed in my tiny room, a fairytale princess trapped in the land of gnomes.

Mrs. Bloom set her fists on her hips and smiled broadly, showing her broken, yellow teeth. "You're wasting yourself in the sweatshop, Pearl," she said. "You could sew for the finest ladies uptown with those hands."

Frieda held out her skirt and curtsied. She gave a little twirl.

"Look how it swings! Frieda, you're a sight to see. Don't let that man of yours get up to any funny tricks when he sees you in that getup. They all have one thing in mind, you know that."

Mrs. Bloom ran her eyes over the graceful outfit again. "I don't know where it comes from, Pearl, but you have what we used to call 'golden hands.' That's what we called skilled hands, hands like yours, back in Galicia. Have you ever heard of that?"

Aunt Rachel's stories about my grandfather's golden hands burst into my mind. Aunt Heddie, too, had stories. Stories of the way he could carve the most beautiful dolls, and of how he used to hammer out his own buttons of silver long before he ever owned the factory. The tsar himself had known that such hands were a national treasure.

"Yes," I said, hiding the pain in my heart for a world forever lost. "I've heard of 'golden hands.'"

"Well, wear it in good health," Mrs. Bloom blessed Frieda as she turned to go. "You should only wear it in good health."

"I hate to take it off," Frieda said. "I don't think I've ever had anything this pretty to wear."

"There's no point in wearing it out," I said. I unhooked the skirt fastenings. "I think it needs a final press. I'll press it at work this week, then carry it back on a hanger. And that's it!"

"Oh, Pearl, I can hardly remember what Michael looks like. It's almost a year since I've seen him. Do you think he'll know me?"

Now undressed, Frieda shivered slightly in a draft from the window. I looked at her tiny waist and the lovely swelling of her round breasts beneath her knit vest. "He'll know you and love you all the more," I said.

I tossed her my big shawl from the bed. It was an all-purpose garment that kept me warm when it wasn't cold enough to wear my cape, and it draped the foot of the bed for an extra blanket all winter.

"Wrap up, Frieda, you'll get goosebumps. We've got to figure out exactly what we're going to do with Michael once he gets here."

We decided that Frieda would meet his train on Sunday at

Grand Central Station by herself. I would be in bed by the time she brought him back to Orchard Street in the evening, so she could have him to herself in the dining room. There was no other place to sit in Mrs. Bloom's apartment. She had so many boarders that she had made the sitting room part of the dining room with a long table running through it.

During the weekdays, we would be at work and Michael would visit the stock exchange. We planned a festive supper out on Monday night with Morris and me, and afterwards a walk through the park so we could talk and get to know Michael. I loved him already, even though I'd never met him. I felt a little shiver of pleasure in my spine every time I thought of him as Frieda's husband—*but not too soon*. Another night we would go to the Yiddish Theater to see *The Jewish King Lear*. We had been longing to see it. I promised to ask Morris to get us tickets.

And so we planned and chatted far into the night, Frieda wrapped up in my shawl cross-legged on the bed, and I snuggled under my blanket for warmth. At one point the boarder in the adjoining room banged on the wall to signal we should be quiet, but this sent us into such fits of giggles we had to hide our heads under the blanket.

No matter that we were exhausted before we even got to work the next day; we dragged along to the bakery and decided to buy coffee instead of milk for once. We knew the machines could sneak up on you if you weren't careful every second.

I spent the Sunday that Michael arrived doing what I always did on Sundays. I borrowed a bucket from Mrs. Bloom, washed all the clothes I had soiled during the week, and hung them on a rope tied across my room. I gave Mrs. Bloom my rent for the coming week, counted the money I had saved, added two dollars, and hid it again under the mattress. The amount grew with painful slowness, but it didn't matter. I had no idea what I was saving for. I began to think I might use it to take a train to Boston for the wedding whenever Michael and Frieda did get married. Or perhaps they would marry here in New York. Nothing had been discussed yet, but I knew a week could change everything.

I dusted and swept my little room and went for a walk in the park. When I came back it was afternoon. I took my usual leisurely Sunday bath on the third floor, washed my hair, and spread it out to dry on my pillow while I went back to reading Gorky's new novel, *Mother*. It was all the rage on the East Side.

When the afternoon sun dropped behind the tall buildings and left Orchard Street in blue shadow, I dressed in my best outfit. I threw the shawl around my shoulders and set out to meet Morris at the Cafe Royale on Second Avenue. It was the most famous cafe on the East Side; a hangout for well-known writers, artists, and actors. Even if nobody famous showed up, you could enjoy the sumptuous music of the Gypsy fiddler who performed there every Sunday night.

Morris greeted me with a kiss on the cheek, as was his habit now. Ever since he had asked me to marry him he treated me with a sort of solemn tenderness, as if one wrong step would cause me to reject him forever.

"Let's find a table. We have so much to talk about. Frieda and I planned out the week as well as we could, but we need your help. Aren't you just dying to meet Michael?"

He laughed and held the door open for me. "Probably not as much as you are, Pearl. But yes, I'd like to get to know him. We have to be sure our Frieda marries a man who's good enough for her."

"Oh, Morris, nobody's good enough for her! But let's think, now. Tomorrow we'll eat out together, maybe at the new deli on East Broadway. What's it called?"

"Goodman and Levine's. I haven't been there yet, myself, but I've heard good things about it."

"And Morris, do you think you could possibly get us four tickets to *Jewish King Lear*, with Jacob Adler playing the lead? It was the role that made him famous, you know. He started out in New York, and here he is in New York again for two weeks. It still has a week to run. Oh, I hope it's not sold out! I know it's a frightful amount of money, but I can pay for my ticket and Frieda's...."

"Hush, Pearl! Of course I'll get tickets, the best tickets they have. Don't worry about the money. I have more money than I

know what to do with, since a charming girl I want to marry won't give me an answer."

"Someday I'll give you an answer, Morris. I feel very close to you. You know that, don't you?"

He groaned.

"Cheer up! Wonderful things are about to happen, I can feel it. Oh, I can't wait to talk to Frieda tomorrow, after she's seen Michael."

Chapter 9

FRIEDA'S FACE was not exactly glowing when I met her at the door the next day, but I was so eager for news I couldn't wait.

"So, how did it go? Do you still like him as much as you did? Is he happy with his school? How long will it take before he gets his degree? Does...."

"For heaven's sake, slow down, Pearl. I don't know the answer to any of that. You'll have a chance to meet him tonight, if you and Morris still want to go out to dinner. Maybe you could ask him a few questions!"

"Hmmmmmm. So it didn't go so well?"

Frieda shrugged as we walked along in the chilly October morning. "He's different, Pearl. He's not the same man I met in Boston."

"But you said you don't know him very well yet. How is he different?"

"Oh, he—I don't know. Maybe he's just not who I thought he was."

"Wake up, Frieda. Here's the bakery. You would have walked right past it."

She sighed.

Fortified with our milk and rolls, we set out again. Frieda shuffled along in deep gloom.

"Well, does he look different?"

"Actually, he does. When I met him he wore forelocks and a beard. Now he's clean shaven, and his chin looks funny. And he doesn't talk so much. When he does talk, it's about money. I think he's crazy about money."

"Not such a bad thing to be crazy about," I suggested. "And don't forget, that's what he's studying now. He has to think about it a lot."

"Yes, but he never says a word about me. It's as if I had no part in his future at all. It's 'I this,' and 'I that,' and 'I am going to be the big cheese on Wall Street someday.' You'd never know we were betrothed."

"Well, you have all week to find out what he's thinking, Frieda. Don't be upset now, wait until you get to know him a bit. And until *we* know him. He's sure to like Morris, Morris is so good. Maybe Michael will loosen up."

We planned to meet Morris downstairs at the entrance to our apartment house that evening, and go on to the restaurant from there. I waited for Michael and Frieda in the dining room, where the other boarders were eating. Frieda made her entrance like the princess she was, her natural beauty brought out by the rose shirtwaist and flowing skirt I had made.

But Michael? Michael slouched at the doorway with his hands in his pockets, peering suspiciously around the room as if it were a place he did not quite trust.

When Frieda introduced us, I looked directly into his deeply set eyes with a smile that was not returned. He appeared to be shorter than she was, but he slouched so that it was hard to tell. Frieda always carried herself regally.

"Frieda has told me so much about you," I burbled. "It's

wonderful that you could come to New York so we could meet you before...." I caught myself and trailed off. Better not mention the wedding until he mentioned it to Frieda. "Let's go down! I'm sure Morris will be waiting."

We descended in awkward silence. I decided to keep my mouth shut; I had almost started trouble. But when we left the building, there was Morris, my dear, dependable friend. He started to chat right away, introduced himself warmly, and described the fantastic growth of the garment industry and his particular place in it.

Since Michael seemed to be interested, Frieda and I let the men fall behind to talk while we walked together, whispering and giggling all the way to the deli. Frieda, of course, was wrapped up in the drama of actually being with her betrothed, but I noticed that many men we passed on the sidewalk slowed down to give Frieda long, admiring glances. She was beautiful. How long did Michael expect Frieda to work herself to death in a sweatshop while he offered no promises for the future?

The dinner at the deli was delicious. We were enjoying ourselves so much that we all ended up ordering apple strudel for dessert, just to prolong the meal. That is, Morris and Frieda and I were enjoying ourselves. Michael spoke very little to me or Frieda, as if Morris were the only intelligent person at the table. And at Morris's every attempt to include us in the conversation, Michael fell into a sullen silence. I was beginning to wonder if I really liked this man.

Morris announced that he had succeeded in obtaining tickets for *Jewish King Lear*, for Thursday night. "It's my offering for this happy week, a magic evening to share. The theater is my gift to the betrothed couple."

Immediately, Frieda's face was suffused with a rosy blush, but I was more interested in Michael's reaction. He scowled and stared at his fork.

"I'm not really a theater fan," he muttered. "Why don't you three go and find a fourth to join you?"

Frieda looked at him in despair.

"Do you know who Jacob Adler is?" I demanded. "They call him 'The Great Eagle.' Even in the meanest roles he makes

everything seem regal. He came here from Odessa when the Russian government banned Yiddish theater, and now even the *New York Times* has praised him. 'He lights up the stage,' they wrote. And you're going to miss a chance to see him?"

Now Michael flushed a deep, angry red. "Maybe I have too much to do to go running around to theaters. Maybe I think it's silly. It's possible to make a good life here, but it takes hard work. I'll spend Thursday night at the library, and you go have fun."

"Fun!" I fumed. "Do you think that's why we go to the theater, to have fun? It's the stuff of life itself if you spend all day bent over a sewing machine until your eyes fall out and your fingers are numb. You might...."

I felt a gentle press of Morris's toe on mine under the table, and I glanced at him. He didn't need to shake his head; the look in his eyes told me I had said enough.

"Well, let's get the checks from the waiter," he suggested. "Pearl and I usually walk in the park after dinner, even on chilly nights like this. Would you like to join us?"

"I have to get some rest," Michael grumbled. "It's not easy to sleep in a hall bedroom. People walking back and forth all night!"

"I slept there for months," I pointed out. "It didn't bother me." I stood up and took a deep breath to calm myself.

"Coming, Morris?"

The next morning I found Frieda sobbing in her pillow. She lifted her head when she heard me. Her face was red and swollen, her eyes puffy from crying, and the flat, lumpy pillow was soaked. I sat at the edge of the bed and stroked her back.

"I—I don't think I can go to work today," she whispered hoarsely. "I tried to get up, but I just keep crying. I won't be able to see anything, and I'm afraid of sewing up my finger again!"

More tears, more sobs.

"Don't worry about going to work," I said. "I'll invent an excuse so dreadful it will melt old Schultz's heart to a puddle of soft ice cream. But tell me, dear Frieda, what happened?"

"It's Michael, of course." She stopped to blow her nose on a soaked handkerchief. "It's all over. He doesn't want to be betrothed to me anymore. So of course I let him go. What else could I do? If his father were still alive, he'd probably force Michael to go through with it, but what good would that be?"

Her eyes filled with tears again, her shoulders shook. She pressed the dripping rag to her mouth.

"Here, take my handkerchief. I have to run. But listen, Frieda, Michael isn't worth a single one of your tears. I didn't even like him. Morris tried to be kind, but I don't think he liked Michael, either. And Morris likes just about everyone."

"What is left for me?" moaned Frieda. "A life of grinding hard work? Never any joy or pleasure."

"Come on, Frieda. If worse comes to worse, we'll find the money to send you home. At least you have a place to return to."

"I would die of shame if I had to tell my parents about this. It would disgrace them. They'd blame me for everything. I'd rather stay here, where I have my little bit of freedom."

She sat up suddenly. "I'll never get out of the factory. I can't save a penny. Oh, what will become of me?" She collapsed onto the pillow again, her shoulders heaving.

"You'll see, things will get better. I'll *make* them get better. Tell Mrs. Bloom you'll be here for lunch, and I bet she'll find some treat for you. I have to go. Old Schultz would eat his heart out, and probably ours, if we both don't show up."

It was too late to stop at the bakery, so I just ran all the way to work. I told Mr. Schultz that Frieda had been up all night throwing up and was running a fever.

"She wanted to come to work, but she was afraid the other girls would catch whatever she has. Then everyone would be out, and you'd have to shut down for a while."

I smiled sweetly.

"Oh, these girls," he growled. "She's not in the family way, is she?"

"Shame on you for even thinking such a thing, Mr. Schultz. Frieda would never let a man touch her in that way." I wanted to slap his coarse, hairy face, but I still worked for him. *Still.*

"I've seen all kinds of things," he said. "But you'd better get to work. Time doesn't stand still, y'know. And girls like Frieda can be replaced easily. It's girls like you, with quick hands, that are hard to find."

I hung my coat in my locker and started to work. Today there was lace for slips, and those skinny little straps to turn and attach, and endless piles of gauzy goods. I liked to work. It kept my hands busy, but my mind wandered where it might.

Not today, though; today I must think of a way to help Frieda get out of the sweatshop, or she would be a withered old woman by the time she was twenty. A lot of girls I knew went to night school after they worked all day. Free classes for immigrants were offered three or four nights a week at the high schools. But we lived twelve long blocks from the nearest school, and Frieda simply didn't have the strength to attend after a full day working. She was afraid to go out alone at night, anyway. The more I thought, the faster my hands flew. Piles of lace and cotton and silk grew smaller and smaller. The stack of finished lingerie grew higher and higher, started to topple, and I started yet another stack. Meanwhile, the kernel of an idea swelled until I thought my head might explode, but I hugged the idea to myself. It was too early to tell yet.

At the lunch break, everyone clustered around to ask about Frieda. Even though the inquiries were all sympathetic, I repeated the story I had told Mr. Schultz. You had to be careful. Although there was a strong feeling of solidarity among most of the girls, you never knew who might use information to their own advantage. And I didn't think Frieda would want me to tell the story of her broken heart.

I hadn't brought anything for lunch, but Clara Lemlich, who worked at another sweatshop, offered to share her lunch with me. She often dropped in at lunchtime when Mr. Schultz ate out, and she knew most of the girls by name.

Clara was well known as a labor organizer. She had spent time making the rounds of the various clothing factories, trying to organize the girls against the wretched working conditions. I had joined the ILGWU, the International Ladies Garment Workers Union, under her influence. Whenever she wasn't

working or organizing, she could be found picketing outside the Leisserson factory. She had even persuaded some other girls to join her in a strike once, but the manager had hired thugs, called "gorillas," to frighten the girls into returning to work. I heard that these "gorillas" would stop at nothing, even violence, to get their way.

Today Clara was telling us about another strike, one that would affect the entire garment industry. "On November twenty-second there will be a meeting at Cooper Union," she declared. "Samuel Gompers himself will be there, and also the head of the Women's Trade Union League. We have seven thousand girls behind us, mostly shirtwaist workers. If nobody else brings it up, I myself will propose a general strike, effective immediately. Girls, are you with me?"

There were many glances exchanged, and a few hands raised. A small chorus of "I am" could barely be heard.

"That's not good enough!" Clara exclaimed. Her voice grew louder. "We are wasting our lives in these miserable lofts for barely enough money to feed ourselves. There are lots of people out there who are trying to help us, but we must help ourselves. In unity is strength, friends! Don't you forget it!"

She leaped up on one of the empty chairs. A pulse beat wildly in her temple as she raised her skinny arm to shake her fist in the air. "Do you love your chains? Is there a single girl who enjoys working here?"

"*No, no, no,*" came the chorus.

"Will you join in the strike for a living wage? For shorter hours and better conditions?"

"*Yes, yes,*" came the resounding answer, and "*Yes, yes,*" again, until we could barely hear the whistle that blew to signal the end of our lunch break.

"Thank you," she said quietly, and walked out of the room.

Thoughts of a strike left my mind as soon as I settled down again to feed fabric to my greedy sewing machine. I wanted to improve working conditions as much as the next person, but my own plans took up all the space in my head. I wanted to try out these plans on Morris. I trusted his judgment, but we had no arrangement to meet tonight. I decided to try the YMHA. It

was dance night, and I knew that Morris still attended the "balls" occasionally.

I found him where I thought I would, on the shiny floor of the auditorium that did double duty as a dance floor. He was dancing a waltz with a chubby, blond girl I had never seen before. She was chattering away a mile a minute, glancing up at Morris from time to time with teasing eyes.

A tight knot of envy clogged my throat. What right had this girl to flirt with him so outrageously?

On the other hand, why not? I had never given him the smallest reason to believe I would marry him. I didn't know if I ever would. And if I continued to ignore the question, would he ask someone else?

The music finally stopped, and I caught his eye. He excused himself and came over to the chairs where I was.

"Oh, Morris, I have a dream that is about to explode and shatter my head in a thousand pieces, and here you are having fun with a strange girl!"

"Strange? Perhaps not so strange to me," he said, laughter bubbling in his eyes. "But tell me, Perele, what is this dream of yours? And does it include me?"

"Well—in a way it does. Come on, if you walk me home I'll tell you all about it."

"But Pearl, you'll have to move if you set yourself up in your own business," he protested, when I had told him my plan. "You can't possibly do it in Mrs. Bloom's apartment. And if you're going to move, why not marry me? We'll find an apartment together, one with a special room for you to fit your clients, something nice. I can afford it. I've lived a long time with my parents. They won't take money from me. They told me to save it."

"Morris, dear Morris. I don't know if you can understand, but this is something I have to do for myself. And for Frieda. It's been such a crazy day I haven't even told you yet, but Michael broke off the betrothal last night and Frieda was too heart-broken to go to work today. I can't bear it; she'll spend the rest of her life slaving for Mr. Schultz, and he hates her. He has a

dirty mouth. You wouldn't believe what he said when I told him she wouldn't be in to work."

"So what are you going to do with Frieda?"

"Once I start making money, I'll be able to pay her wages to help me. She's very obliging, and I know she'd do anything for me."

He laughed out loud. "You have lost your mind, little one. Do you know how much money it takes to rent your own apartment? And what about a sewing machine, a dressmaker's model, and all the notions—fine scissors, tapes, seam rippers, pincushions, measuring tapes, muslin, all the bits and pieces a good seamstress needs?"

"Don't you dare laugh at me," I said. "Do you think I haven't worried about it all day, while I sewed endless lace appliqués on endless lingerie?"

"But how will you raise the money?"

I touched the diamond nestled in one ear. "I'm going to sell my diamond earrings, Morris. I wanted to sell them to go to Russia when my Aunt Rachel was so ill, but something held me back. Maybe she didn't want me to. She was really glad that I was here in America. But now I'm sure, I'm sure as that tree over there, that now is the time to sell them and start my own sewing business."

"But if you sell your earrings, you'll have nothing left. Don't do it, Pearl, let me help you. I'll lend you the money. You can pay me back if you make good."

"Not *if* I make good, *when* I make good. I know I can do it; even old Schultz likes my work. And Morris...if we do marry, I want it to be because I love you, not because I owe you."

"So?" he asked. "You come to America and already you're an American? Our people never had to love each other, and we've been marrying for five thousand years." He took my hand in his, and rubbed it. "So cold and so stubborn."

"Please wait. Let me see how this project works out, and I'll think about marrying you. I have to do it myself." I giggled. "Compared to facing my Aunt Heddie, this should be a piece of strudel."

"Let me help you a little, at least. A cousin of mine is in the

Diamond Cutters' Union. He'll know exactly where to sell your earrings, for a better price than you could possibly get on your own. Let me talk to him about it."

I stopped on the dark sidewalk and pulled a diamond from each ear. "Here, this is how much I trust you. My entire life is in your hands."

He shook out a handkerchief, neatly wrapped up the earrings, and replaced the little bundle in his pocket.

"And how do you know I won't sell them and use the money to buy a fancy uptown apartment?"

"Morris, you are an angel," I said, and tucked my arm in his.

Chapter 10

MICHAEL MOVED OUT of Mrs. Bloom's hall the next day. Frieda was still too upset to go to work, and I was afraid that Mr. Schultz would be suspicious if she was out only one day. So I went to work as usual, and Frieda stayed in her bedroom, recovering from her broken heart. If any further conversation passed between the mismatched pair, Frieda never told me, and I never asked. In fact, I never mentioned Michael's name to Frieda again.

Morris, meanwhile, had bought three tickets to *Jewish King Lear*. We met him at the theater entrance on Thursday night. Frieda was still subdued, but Morris seemed in especially high spirits. He must have paid a fortune for the tickets; we had seats in the third row, center. Each of us thrilled to the tragedy of betrayal and unrecognized love in our own way. Frieda started to weep someplace in the second act, and didn't stop until the play

was over. I managed to keep from crying until the third act, but then gave myself up to sorrow for the old king and his daughter, and sobbed until the end. I even caught Morris wiping away a tear or two.

We were in no hurry to leave the theater, since Frieda and I needed time to compose ourselves. It was fun to watch the members of the audience file out, richly dressed women in furs and jewels, and men in dark suits and ties. One of the women walking up the aisle reminded me of Aunt Heddie—or could it really *be* Aunt Heddie? Who else would wear a hat like that? And to the theater? I stared down at my knees trying not to be noticed. I was not ready for a noisy, tearful reunion, and I was not sure if I would ever be ready. It hurt me to think about her. I felt guilty for betraying her trust.

When the huge hall was empty except for us and two cleaning men, we left the theater. We walked half a block and stood at the curb, waiting for a break in traffic to cross the street. I glanced down the side street for a moment, and my heart almost stopped beating.

"Frieda, look," I whispered.

Jacob Adler strolled along the sidewalk wearing a silk top hat and carrying an elegant silver-headed cane. He looked even more handsome than on the stage. From his regal posture it was impossible to tell that half an hour ago he had been a broken old man. Not one of us dared move. We stood rapt until he and his little parade of followers passed right by where we stood. We were hypnotized not only by Adler, but by the faces of the people with him, shining with enchantment.

"Oh, Morris," Frieda whispered, forgetting her recent woe. "This has been the most wonderful night of my life."

"I bet you're going to have a lot more wonderful nights," Morris said.

He and I traded glances. We both hoped the emotional play had purged Frieda's soul of the despair she was wallowing in. I was afraid that if she didn't overcome her misery, she would really make herself sick.

"And you, Pearl?" Morris teased. "Is this the most wonderful night of your life, too?"

"Hmmmmmm. So far, I suppose. But we may be able to top this." I looked at him and grinned.

"The evening isn't over," he said. "If you'll stop here with me for a cup of tea, I'll tell you something that will add a lot."

Once we were seated in the glow of candlelight, Frieda looked at me with inquiring eyes. She was wondering if Morris were going to ask me to marry him, but I knew he wouldn't be so tactless as to bring the subject up. He might have something to tell me that was almost as important, though. I chatted until he had ordered tea and honey cake for us, and fell silent.

"I have news, Pearl. My cousin has an offer for your earrings. It is the best you are likely to get."

Frieda groaned. "Your diamond earrings! Oh, Pearl, what are you thinking of?"

I grabbed her hand under the table and squeezed it. "Shush, Frieda, and listen."

"My cousin tells me there isn't much point in trying to shop around in the diamond industry," Morris went on. "You're dealing with experts, and they know exactly what every diamond is worth."

A heavy weight began to gather in my heart. Perhaps the earrings weren't worth so much, after all.

"He says the best he can get for you is four thousand dollars, and that's because they're an especially fine pair. Of course...."

"Four thousand dollars! That's a fortune! Oh, Frieda, Frieda, we're all set." I was so happy that my eyes filled with tears. I saw a double candle flame before me and two Morrises before I blinked them away.

"Will you be still for a moment, and listen?" Morris asked.

"Will someone tell me what you are talking about?" Frieda asked.

"In a minute, Frieda, I promise! Morris, what more do I have to know?"

"That four thousand dollars is the wholesale price. You'll be selling to dealers, and 'wholesale' means the price dealers will pay. If you went into a jewelry shop and saw those same earrings on display, you'd find them priced much higher. That's the retail price, what the customer has to pay."

Greed poked me in the shoulder with a sharp claw. "So why don't we sell them directly to a customer? My father used to sell his jewels directly to clients."

"Your father must have had a good name, and he obviously had connections. Things are different here in America. You don't have a store. If you give them to a jewelry store to sell, the owner might sell them and cheat you." He fell silent for a moment, as the waitress set our tea and slices of cake on the table. "At least four thousand is an honest price; my cousin wouldn't lie to me, and he's in the business."

"Then take it," I said. "It's more than I ever dreamed of. Oh, Frieda, we're going into business for ourselves! No more of that filthy loft, no more of Schultz's stinky breath and sweaty hands." I lifted the cup to my mouth, found the tea scalding, and set it down again.

"Morris, when will I get the money? I'll have to look for a sewing machine. Or maybe I should get an apartment first? And where do I find customers? I know I can please them. If they give me a chance. I'm the only seamstress in history who ever pleased Mr. Schultz. And when do I...."

"But how will you make enough money? And I *have* to stay at the sweatshop. Else how will I pay Mrs. Bloom? I don't have a sewing machine, or diamond earrings to sell. But I'm so happy for you, Pearl." With that, Frieda burst into tears and nearly choked on a piece of honey cake in her mouth.

"We'll work it out, Frieda, honestly, we will. I'm not quitting this minute, either. I have to be set up for my own customers, first. Maybe...." I looked at Morris. "Maybe I shouldn't even mention it to Mr. Schultz right away."

"Not a word, either of you. We must do this right. And the money's not a problem. I can get it in a few days. But you have to go to a bank, and open an account to put the money in. You can't walk around with all that cash; you take out what you need as you go along."

Frieda had stopped crying and dried her tears. "I don't know how you can be so brave," she whispered.

"I'm not brave," I told her. "I'm desperate."

• • •

It was mid-November. I had so much to do, and so little time to do it! I gave up eating lunch in the sweatshop and spent those precious minutes running all over the city trying to find an apartment that was big enough for my work, yet cheap enough for my money to last a long time. I had no idea how long it would take to earn enough to live on.

It was pure luck that when I needed time more than anything else, I had it, because I was soon on strike. At the meeting at Cooper Union in November, Clara Lemlich, the teenage union organizer, offered a resolution that a general strike be called immediately. A great wave of excitement swept through the crowd. People screamed, stamped their feet, and waved their scarves. When the chairman managed to quiet the crowd enough to ask someone to second the motion, the entire mob shouted "I second! I second!" The chairman, shaken to his core by this outburst, declared the strike in effect.

Week after week the strike went on. Most of the loft factories were closed, but a few factories tried to use "scabs," people who would work in spite of the strike. In the first month, 723 striking girls were arrested for blocking the entrances to prevent the scabs from working. Miraculously, the girls were aided in their cause by older women of prominent, wealthy New York families. Anne Morgan, a member of the famous banking family, provided bail money. Exclusive Wellesley College students pitched in and donated $1,000.

The most thrilling part of the strike were the working girls themselves. Many of them turned out to be natural leaders who had never before had a chance to be heard. They were invited to speak before men's clubs, women's clubs, church groups, schools, and colleges. In simple but moving language, one girl after another told the audience of her working conditions, her wages, and the pinching poverty of her life.

The girls were brave beyond understanding. A group headed by Clara formed a picket line in front of a factory one morning, singing Russian and Italian working-class songs as they paced by the door two by two. Around the corner rushed a dozen burly, unshaven men, the famous "gorillas."

"Stand fast, girls," Clara shouted.

The gorillas rushed the line. They struck Clara to her knees on the sidewalk with clubs, then flailed and punched at the other girls. They opened a space for the frightened scabs to slip through the broken line of picketers. The girls screamed and tried to fight back as men's fists struck at them again and again. Finally, a police wagon arrived, and the officers pushed Clara and two other badly beaten girls into the wagon. The thugs ran off.

I had joined the union after Frieda's accident with the sewing machine, and I supported the strikers with all my heart. I wouldn't have worked during the strike for any amount of money, but I felt my time would best be spent by hunting for a suitable apartment, where I could work toward my dream. It was almost as difficult as walking the picket lines. I did vow, however, that if I ever had an opportunity to hire someone to work for me, I would look for ways to make the work pleasant and rewarding.

I worried constantly about Morris. He was on strike, too, since he also worked in the garment industry. He made a good salary and enjoyed better working conditions, but he walked the picket lines with the Pattern Makers Union. He was such a gentle soul I did not know what he would do if his line were attacked by gorillas. Strangely, it never happened. It seemed these gorillas preferred to attack lines of young girls, much easier targets than the men.

That dreary, cold winter wore on and on. The suffering of the poor girls was horrible. Without their wages, many actually died of starvation. The union officers did the best they could. At the union hall, they set up a relief station and passed out one bottle of milk and one loaf of bread to strikers with small children in their families. If they knew a girl lived alone without a family, they gave her the relief rations anyway, with no questions asked.

Finally, in mid-February, the strike was settled. The strikers won many improvements in working conditions, but they failed to win formal recognition for the International Ladies Garment Workers Union, which they had asked for.

Frieda and I managed quite well during the strike, thanks to

Mrs. Bloom. Frieda joined the picket lines when she felt brave enough, and announced that it was easy after working for Mr. Schultz. Now without any money, she told Mrs. Bloom that she would move out into the street. Mrs. Bloom, our dear, good witch, insisted that Frieda stay and eat at her table until the strike was over, at no charge.

I felt quite wealthy with my earring money now safely in a savings account earning some interest. I tried to pay for my room and board, but Mrs. Bloom would not accept a penny. "The least I can do is help the cause you poor girls suffer for," she declared.

She even bullied us into partaking of steaming coffee and rolls that now miraculously appeared on her dining room table every morning. Bless her heart! Often I wished that she were my aunt, instead of Heddie. I was thinking about Aunt Heddie more and more often.

One result of the strike was the spirit it aroused on the East Side. Many other workers had added their strength to ours, and by the strike's end, union local twenty-five had grown to ten thousand members. A wave of hope and determination swept over the workers and their families; they had discovered a new sense of dignity on the picket lines. Now it seemed there was no end to what poor immigrants could accomplish. Eager to fulfill my dreams and full of plans and ambition, my emotions rode high on the wave.

Chapter 11

I MANAGED to find a tiny apartment, only a few blocks from Mrs. Bloom's. The place had gas lights rather than electricity, but that was fine. I wasn't ready to buy one of the new electric machines yet. Morris and I talked about it, and we decided I would offer to buy Mrs. Bloom's old treadle. I had already worked with it, and the machine was in good condition and easy to use.

When I broached the subject to our beloved landlady, she was determined to make a gift out of it. "For such a fine seamstress, sewing machines should arrive like manna from heaven," she announced. "When you're a famous dressmaker, I'll be able to say I gave you your first machine."

"Mrs. Bloom, you've done too much for us already," I said. "I can afford to pay you now."

"No payment, no payment," she insisted. "It's a *mitzvah*, a

good deed we're required to do. And I don't need the money. I'm doing so well, look, did you notice I took the bed out of the hall? I don't need the few extra dollars anymore, and it's nicer for the boarders. I've raised everyone fifty cents a week, and my own rent hasn't gone up."

She winked at me with a drooping lid. "If we go on like this, Perele, we'll become as rich as one of the Morgans."

And so Morris borrowed a cart from a street vendor and we wheeled the heavy sewing machine over to my flat. I had a sitting room and a tiny alcove to squeeze a bed in. The sitting room would be a work room, fitting room, a show room, and anything else I needed. There was a small sink in the dark closet that opened off the big room. The bathtub was on the first floor below me, and a toilet stood in a closet in the hall on my floor.

The best thing about the place was an old hardwood floor that was grimy and worn. Morris took a day off from the picket line and sanded it on his hands and knees, exposing the handsome wood grain. I bought some paste floor wax and rubbed it in, then stood barefoot on fresh rags and shuffled about the room to buff it. When it was done, the floor shone with such a deep, rich glow that it lit up the whole room. It was my only luxury except for a full-length mirror with a smooth, golden oak frame that I bought. My clients would look elegant when they saw themselves framed in it.

I never did go back to Mr. Schultz. By the time the strike was over, I had everything I needed to start out on my own. Morris returned to his work, of course, and Frieda went back to the loft. She seemed almost relieved. She was a timid girl, and at least she knew she could handle her job with Mr. Schultz. But I made her promise to give it up as soon as I had enough business to need a second seamstress.

Without any access to a kitchen, I asked Mrs. Bloom if I could continue to show up for dinner every night for two dollars a week, a generous amount. She started to mutter about not taking any money, but I grew quite fierce and swore that I would never sit down at her table again if I didn't pay for it. She gave in and accepted my money. The other diners, used to

seeing me with Frieda at the table, always saved two adjacent seats if we were late.

And so I remained close to Frieda. We told each other secrets, shared whatever news we had, and generally lifted each other's spirits. As one who had shared my journey over deep waters and given me the courage to leave Aunt Heddie's house, Frieda had a special place in my heart.

I spent the first few days in my tiny apartment running up some dressing gowns and dresses as samples of my work. Once again, Morris saved the day by drawing patterns for these garments, using my suggestions for seams and details. He showed me how to cut fabric in different ways to get different drapes, and how the drape and heft of the fabric determines the style. I learned a lot about design working with him. I realized that for all my skill with a sewing machine, I had never learned much at the loft. It was truly a dead end.

I made a few skirts, and a waist, drawing the patterns myself the way Morris had shown me. I decorated them with pleats and ruffles, and thought they looked quite grand. If only I had a few clients—or even one! Money was not a problem; I had quite a bit in the savings account, but I knew I could not live on it forever. And there is nothing left to sell, I thought. I touched one naked earlobe that had once sparkled with my icy inheritance.

The only other inheritance were the memories that rushed in to fill the silence. The weeks I spent alone in my little sitting room were the first since I had arrived in America that were not crowded with activity. I fell into a state of melancholy and wept for all I had lost, until my aunts appeared to me in all their life and vigor. Glowing with love and encouragement, Aunt Rachel stood at my elbow, watching my hands as the bright fabrics flowed through them. "It will be yours, Perele," I heard her whisper. "Whatever you wish will be granted."

Aunt Heddie appeared, too, her face flushed with emotions, her heart beating wildly in her heaving breast. "Why did you leave those who love you?" she wailed. "You were my own daughter. Why did you leave us?"

I cringed at this vision, and thought about her constantly.

What had led to the cries and pitiful whines she used to keep her children in a state of endless remorse? Why all the shrieking, groaning, and threatening? Why did she feel she had to dominate everyone in the family?

Perhaps parting from her family in Russia was too much for her. Perhaps she was so lonely in her new country that she had to cling to those she loved with barbed hooks. When she filled our ears with warnings, perhaps she was thinking of Russian streets that ran so often with Jewish blood. Maybe the weight of centuries bore down on her. *Maybe I should have been kinder.*

My father too, was often with me, holding out the little box of earrings, smiling his bitter smile. Did he ever think of me? Did he ever regret the harsh letter he sent? He must be all alone now, and who knew where? I didn't even know if he was still in touch with Aunt Heddie.

After two weeks of this torment I couldn't stand it any longer. I would not sit and brood. I had come this far, but it was just the beginning. I would keep busy and find clients or what had it all been for? Morris had promised to send me any woman who asked him for a custom-fitted dress, but those requests did not come often. His real work was developing patterns for the factories.

One evening at Mrs. Bloom's I asked the group clustered at the dinner table if anyone knew of a woman looking for a seamstress.

"I might," said an old lady who cleaned houses. "One of the women I clean for has all her dresses custom-made. I think she already has a seamstress, but I can ask. I just hope I remember."

"I'll remind you," Mrs. Bloom said. "And what about you, Betty, don't you run into any fancy dressers at the office where you work?"

The young woman shook her head. "The office is full of men," she sighed. "The only women I see are the other secretaries, and none of us can afford a seamstress!"

Frieda and I exchanged glances. Hers was full of concern; mine, I hoped, reassuring. The last thing I wanted was Frieda worrying about me. She was doing as well as she could, although she looked pale and worn out to me, with blue circles

under her eyes. Working for Mr. Schultz had always been too much for her.

And so I waited in my room day after day, falling deeper and deeper into despair. What would become of me? Of course I could always go back to the loft with Mr. Schultz. Probably, with my experience, I could find work in a more modern factory with better conditions. But it would be for the rest of my life, and I could not bear to think of it.

One night Morris showed up at Mrs. Bloom's just as we finished our dinner. I hardly wanted to see him. He had helped me so much that I didn't want him to do anything else. It was time for me to manage on my own.

Frieda ran to greet him, and Mrs. Bloom insisted that he sit down with us and have a cup of coffee. He folded his topcoat carefully and set it on the sofa, then drew up a chair.

He studied me gravely for a moment. "Why such a glum face?"

"It was all a mistake!" I cried. "Everything was for nothing! I'll never get a customer, no one will ever employ me as a seamstress, I don't know what I'll do, I'll die. Oh, I wish I had never left Russia."

I burst into tears in front of everyone, completing my humiliation. Frieda threw her arms around me, murmuring, "There, there, it will all work out."

"Where's your spirit?" shrilled Mrs. Bloom. "You have it all! Talent, and strength, and *my old sewing machine!* All you need are clients. What are you crying about?"

A general murmur of agreement rose among the boarders, who nodded, sighed, and shook their heads.

"But how am I to get clients?" I wailed. "Nobody knows me. I can't go out in the street and beg women to let me dress them. Oh, what should I do?"

"I have an idea. I'll tell you if you'll stop crying and listen to me," Morris said.

I lifted my head and wiped away my tears with one of Mrs. Bloom's not-too-clean napkins. I shuddered, I almost gagged, with emotion. Not only my business idea, but my whole life seemed one long mistake. My own family would haunt me

forever, but I didn't say that.

Morris pulled his chair closer. "I have a great idea. You're good enough to find work anyplace, so why not go to the dress shops and look for a job? They only hire seamstresses part-time, but...."

"How will that help me?" I demanded, the tears starting again. "Everyone knows they don't pay much. After all the misery we went through in the strikes, I'd have to take non-union wages again."

"Listen, just listen. The women who buy at the small shops have alterations done. You'll meet them, measure them, alter their clothes for them. You can convince them you're the finest seamstress in New York. You'll have them eating out of your hand in no time. Believe me, a lot of people start out worse."

"I already started out worse. I worked in a loft."

I thought about it quietly for a minute. I licked a stray tear that had rolled down my cheek.

"Are you so hungry for the bitter taste of tears?" he asked.

I found work as a seamstress at Draper's Dress Shop on East Broadway, one of the nicer areas in the Lower East. Many professional people lived close by, and it was a great social distance from Orchard Street. I had a little closet in the back of the shop with a naked light bulb and a sewing machine. I did all my fitting and pinning in the ladies' dressing rooms.

At that time, sizes were very variable, so that most of the women who bought dresses needed alterations. Dressing gowns, those tailored robes that usually fastened with a cloth sash, were very much in demand; they were one of the most popular items. I wondered why. Did the ladies lounge about the house so often they needed a variety of dressing gowns? These gowns brought little work for me, since dressing gowns were cut so loose they would fit any woman. And they were not intended for wear anyplace but at home.

After I was at Draper's for a month and felt secure that I could do the work required of me, I started to chat with the women as I tucked and pinned and fitted. One day I was fitting a lady who had chosen three dressing gowns. She was a beauti-

ful young women with straight, shining brown hair and glow-
ing, olive skin. She was so small that all the gowns had to be
shortened to save her from tripping over them. She wrapped
herself in one and I pinned the hem.

"That will do," I said. "I'll just measure the length of the
other two against this one."

She turned to take off the robe.

"Ma'am, may I ask a question?"

"Of course. What is it?"

"Why do you want three dressing gowns when we have so
many pretty dresses in stock?"

She looked at me quizzically with great hazel eyes for a
moment, then burst out laughing. "My dear child, hasn't your
mother told you what the dressing gowns are for?"

"I don't have a mother," I mumbled, "but I'd be grateful if
you'd tell me."

"I am in the family way," she declared. "Do you know
what that is?"

"Yes. It means you are going to have a baby."

"And since I don't feel like lounging about the house in my
husband's pajamas while my baby is growing, I buy dressing
gowns, the prettiest ones I can find. Look, aren't these lovely?"

"They're perfectly beautiful," I said, smoothing the lace on
the pink satin gown she had just taken off. "But you can't go
out in these! What will you wear out?"

"Ah, child, I can see that you don't have a mother. As the
months wear on and we grow big in the belly, we don't go out
at all. Oh, maybe at night, wearing our husbands' coats to hide
our shape. We might take a bit of a walk for our health on our
husbands' arms. But never in daylight! How would it look?
What would we wear?"

"Ooooooooh."

I helped her button and fasten the smart tan suit she wore.
I stared at her. A new idea rushed into my head and bloomed
before it even had time to take root.

"What is it now?" she asked, and smiled. "More ques-
tions?"

"You don't have to live in dressing gowns," I said. "I could

make you a dress that would change whenever you change. It would flow, and give you nice lines, even months from now. Oh, please let me!"

"I've never seen such a thing. I'm afraid it would look dreadful."

"I'll...I'll make a drawing first. I'll show it to you when you come in to pick up the dressing gowns. If you like it, I'll make it up for you. I'm a first-rate seamstress, I was the best one at Mr. Schultz's factory. I can make a sewing machine sing...."

"All right," she said. "I'll look at your drawing when I come back. How long will it take you to do the hems?"

"Ah, three days, ma'am. We're behind in filling orders."

"Three days for hems? You certainly are backed up. I'll see you Thursday, then."

"And your name, please, for my work order?"

"Mrs. Dubrow. And what is your name?"

"Perele. I mean, Pearl. You'll see, you'll love the dress I will design for you."

"Thank you, Pearl," she said. "But don't forget the dressing gowns. I love them, too."

She swept out of the dressing room.

I sat down on the bench, trembling. Oh, what would a woman like to wear as she waited for her precious baby? I must work out some sketches this evening. Maybe pleats from a yoke, or gathers like a smock, or elastic inserts? It would have to be really comfortable, and look presentable, too. But I must get busy!

I gathered up my dressing gowns and took them to the little closet where I sewed. I would do them this afternoon after a few more fittings I had on my schedule. The hems would not take three days, but I was glad I said they would. I needed every second I could find to design a dress for Mrs. Dubrow.

Chapter 12

I SPENT the evening working up twelve different designs for Mrs. Dubrow. I could not make up my mind which was best, so I cleaned up the sketches and drew each one on a fresh piece of paper. I tacked them up in groups on the woodwork, and went to sleep.

I slept deeply for about an hour, then woke from a nightmare in which Aunt Heddie was waving a butcher knife and threatening to cut out my heart. A black cave inside me gaped open, swallowing me inside out while I lay in a cold sweat of terror. I leaped from the bed, turned on the light in the sitting room, and was confronted by the designs pinned up on the woodwork.

My drawings distracted me. Slowly, my mind emerged from that dream of horror that pursued me even in my awakening. I studied the sketches carefully, desperate to focus on something

real, and finally saw what I couldn't see last night. Four of them were simply no good; they looked too much like the dressing gowns that were in the stores. An expectant woman would look fine in one until she began to bulge, and then she would resemble a potato wrapped in a napkin. I crumpled them up and tossed them in the wastebasket, where they unfolded with a strange rasping sound.

I tried to go back to sleep, but tossed fitfully as dark images of my dreams returned. The harder I tried to sleep, the more sleep evaded me. I turned on the light once more.

There was another group of sketches that seemed well enough designed, but had plain, round necklines. As I studied them, I realized a woman would want something to draw people's eyes away from her body and toward her face. Her body would become heavy and weighted, but her face would radiate joy in the coming baby. I crumpled the designs with plain necklines, and they flew to join the others in my wastebasket.

Good. I had only four designs left to choose from. With a little shiver of satisfaction, I went back to sleep and slept soundly until the light of a golden dawn awoke me. I dressed for work as usual, but my mind was on my designs; tonight I would have to choose the sketch to show Mrs. Dubrow. I did not want to show her more than one, because only the very best would do.

The designs danced in my head while I fitted and pinned all day at work. By evening I knew which one to choose. It had a soft, draped neckline to draw attention to the face, a high waist, and an accordion pleated skirt that would expand as the lady expanded. I started to toss out the other designs, but a whisper in my mind stopped me. I left them pinned to the woodwork.

Mrs. Dubrow showed up at eleven o'clock the next morning. I was so nervous I could hear a pulse pounding in my ears. I was afraid that I might throw up.

First, I showed her the three dressing gowns I had shortened, which I knew would please her. She gathered them up to take to the sales clerk while I shuffled and cleared my throat.

"Oh, Mrs. Dubrow, I have a sketch to show you. We talked about it when you bought the dressing gowns, remember?"

She stopped and looked at me vacantly, even impatiently. "Yes," she finally said. "I do remember. Something about a garment other than a dressing gown?"

She paused delicately.

"Yes, something else. I call it a 'tea gown,' because it will be just perfect to wear when you invite friends over for tea. It will be so pretty you'll be sorry to put it away after the baby comes, you'll want to go on wearing it...."

"Come, child, show me your design, I must be getting home."

Flushed, ashamed, aware that I had talked too much, I held out my best design with trembling fingers. Her hands were full with a purse, umbrella, and the dressing gowns, so I kept holding it out while she examined it endlessly.

Finally: "How interesting. I've never thought of accordion pleats for this time of waiting. I don't know if anyone has."

"Yes, ma'am, see how they would expand and fall in graceful lines...?"

"But the pleated skirt is attached to a fixed waistband," she said. "If the waistband doesn't expand, too, nobody could wear it in the last few months. That's when it's so hard to find anything at all."

I hadn't thought of that, and it struck me dumb. I stared at her for a minute, still holding our my poor sketch for her scrutiny.

"Oh, I forgot to mention the gown will have an elastic insert at the waist for comfort."

"Ingenious! But there must be some reason why no one ever thought of such a gown before. I don't want to waste your time in making it up. I might find it wouldn't do at all."

"But I don't mind making it up, maybe in muslin for a pattern model. And then, if you think you'd wear it, we could make it up in...."

"Please, dear, it's not for me. You must excuse me, I'm getting tired." She looked at me sympathetically for a moment. "My husband would never approve of such a thing," she said, softly.

She swept out of the little alcove and was gone, while I

stood there with my precious sketch, trembling with rage and disappointment.

"The worst part of it is, I think she really liked it!" I quavered, telling my tale that night at Mrs. Bloom's dining table. "But it's almost as if she were afraid to try something new."

"So what are you going to do now?" demanded Mrs. Bloom. "Hide your head in the sand like a cow? Shorten dresses at Draper's the rest of your life?"

"What do you expect me to do? Keep finding customers who don't know what they want? Who can't recognize a good idea when it's right under their noses? Every bit of my energy went into that design. I know it's good! How much of this do you think I can stand?"

"Oho, listen to the little princess. How much can she stand? She crossed an ocean alone when she was a child. Now she can't stand being turned down? Who is she?"

There was a general murmur of agreement. Frieda patted my hand under the table. "Maybe Pearl needs some time to think about it."

"To think, she doesn't need," Mrs. Bloom pursued. "What she needs is to get busy. And what the world needs is something new for women to wear while they wait. Pearl, what do you call your creation?"

"A tea gown, because it's the perfect thing to wear when you invite your friends in for tea."

"Do you think you should talk about such things in front of the men?" one of the boarders asked. It was Mr. Radowicz, whom I had almost walked into in the hall one day.

I blushed.

Mrs. Bloom spluttered. "Mr. Radowicz, do you know where babies come from? Would you deny the plan that God gave the world? Is it too much garlic for your pink ears?"

This time *he* blushed while I glanced at Frieda out of the corner of my eye, only to catch her sneaking a glance at me. We started to laugh, couldn't stop, and finally collapsed in each other's arms, giggling wildly.

Somehow, the scene at the table revived my confidence.

Mrs. Bloom was right. Who was I? I was the granddaughter of Avrom the Buttonmaker, that's who I was. Maybe that was my inheritance—my golden hands. Besides, I either believed in my work or I didn't. And I had to, since it was all I had. I walked back to my little room that night with steel in my backbone.

Over the next week, I spent every evening refining the drawing. I did a sketch of the inside of the gown showing the elastic insert, and made several drawings of the same gown with women at different stages along their journey to bring forth life.

I thought of the drawing lessons I used to love in the big house in St. Petersburg. Sometimes Aunt Rachel would join me. We would sit together in the sunroom working on sketches while our tutor paced back and forth behind us, muttering. I still missed my dear aunt, and knew that I always would. No one could ever replace her in my heart.

When the drawings looked polished, I brought them to work and showed them to Mrs. Draper. She owned the shop together with her husband. She studied my work quietly.

"Pearl, you are a genius. Nobody has done this before. However did you think of it?"

I decided not to mention Mrs. Dubrow. "It just came to me one night, ma'am."

"There's only one way to test a new design; that's to try it out on the person who will wear it. We're lucky; my daughter is in the family way. Why don't you make it up in a heavy, sky blue silk—I'll pay for the fabric—and I'll give it to her for a gift. We'll see what she thinks of it. If she likes it, we may have a golden egg, you little goose."

I brimmed, and was afraid I might spill over.

"Thank you. I'll have it done as soon as I can."

I endured fits of terror; I knew now how few chances I would have to sell my idea.

I made a pact with myself; if it doesn't work this time, I'll give up on it and just be the best seamstress I can.

I made a pact with God: please, please, let her love my tea gown, and I'll never do anything bad again.

I even made a pact with Aunt Heddie: please don't be mad

at me anymore; it's bad luck. Someday I'll make peace with you, I swear I will.

And all this time I worked frantically on the pattern, bought the fabric, and put the whole gown together with hands that had suddenly acquired a slight tremor. It took several evenings and an entire Sunday when I was supposed to meet Morris at a cafe. I asked Frieda if she would meet him and tell him I was ill. Even she didn't know what I was up to.

While my hands flew that Sunday I thought about Morris. Why didn't I want him to know about my project? Dear Morris was so kind, and so good, and so eager to take over and make everything easy for me!

This was *my* idea, *my* design, and even if it meant failure, I had to do it myself. I bristled when I thought of how Mrs. Draper had said, "We'll see," and "We may have a golden egg...."

Who was this "We?" It was *my* idea that was just now coming into existence as the bright silk ran like water beneath my needle, and I was delirious. Maybe if she likes it...maybe someone else will like it...maybe I'll have a shop...maybe...and the tea gown swayed from a hanger on the door, complete and resplendent.

"My daughter just loves the gown!" burbled Mrs. Draper. "She's begun to show, but the gown hangs so gracefully she could almost wear it out of the house." Mrs. Draper giggled. "Well, I'm afraid we're not quite ready for *that* yet, but you know what I mean."

I wondered if she was going to pay me for my work, but I was too polite to ask.

She read my mind.

"Pearl, I'm not going to pay you for the gown. I'm offering a rare opportunity for a girl like you. Just think, you have a gown of your own design out in the world, being worn as you intended." She paused to sigh and roll her eyes, to show how lucky I was.

"My daughter has a lot of friends around the age when young couples start families. I'll ask her to give your name to anyone who admires the gown. I'm sure you'll get some orders.

Meanwhile, I'll order two more tea gowns for her, maybe in a fabric that isn't so dressy. Cotton or rayon would be fine. I'll pay you, too. Four dollars each. How's that?"

"That's fine, Mrs. Draper, thank you."

I was grateful. Yet it didn't seem quite right to me that she didn't pay me for the gown her daughter loved. It wasn't just the labor; it was the idea. Her daughter had the original of a design that was going to revolutionize women's lives. I knew it. I could feel it and taste it, and I left work early that afternoon so that I could shop for fabric for the first two orders of my revolutionary design.

Before I had finished the two tea gowns for Mrs. Draper's daughter, enough of her friends had seen the first to want copies for themselves. Seven orders came in at once and I was overwhelmed. I told Mrs. Draper that I would have to quit working at the shop, and gave her a week's notice.

She was outraged.

After all I've done for you, you up and quit," she fumed. "Look, Pearl, I have a better idea. I'll find another girl for alterations, and you can stay right here and make your gowns. We'll sell them in the store. I'll take a percentage of your earnings, of course...."

"Thank you, Mrs. Draper, but I feel that it's time I was on my own. I have a little flat to myself, did you know that? It's furnished for a dressmaker because that's what I am, a dressmaker. But I thank you for your help."

She fussed a bit more, but we parted friends.

What sweet joy to be in my own little room, working on my own designs! When I lifted my eyes from the sewing machine I was confronted by the drawings left on the woodwork, and I decided they were good, although not as good as the one I had started with. But they would be useful, as some women would want to have a choice.

One day Morris showed up at my door, knocking like thunder.

"Where have you been, Pearl? I stopped in at Mrs. Bloom's during dinner last night. You've worried Frieda to death. She

said the last time she saw you, you were upset because some woman had turned down a design...." He caught me in a massive bear hug.

"You have to treat your friends better than that. Frieda can't be running all over the city looking for you after one of those days in the loft."

"But she won't be working in the loft much longer, Morris. Look!"

I lifted one finished gown from the door, posed it in front of me, and held out the skirt with a curtsy.

He examined it carefully. "It's very nice, Pearl, and a professional job. But you can do gowns a lot more elaborate...."

"Oh, Morris, you don't understand." Carefully, I turned the dress inside out and held it up again, with the elastic insert across my middle.

I saw his look turn from astonishment to comprehension, and finally to admiration. He took a deep breath.

"Pearl, I think you've done it. You're a genius! But it might be difficult to sell at first. We have to find a way to market it."

"It *is* already sold," I retorted. Just then I thought I loved him, and I loved the fact that he appreciated what I had done. And I also loved the dress as I carefully replaced it on the hanger.

"I have orders for seven more, and these two are already done," I said. "You see, if you let me take care of my own business I do very well, thank you."

He turned away, actually turned his back to me, his shoulders in an odd slouch. I wished I could take my hasty words back. I wished it very hard.

He turned to me again, his face stricken. "I didn't mean to take your work away from you, Pearl. It's just that I want you to succeed so much, I can't stop trying to help."

"Oh, I know that, dear Morris. Forgive me for being so sharp, but I'm terrified. What if this doesn't last, what if these women decide it's a terrible gown, what if...."

He stopped my chatter with his own lips on mine. It was so pleasant I did not want it to stop, and I slid my arms around his neck and drew him closer.

Chapter 13

THERE WAS a need for something attractive that women could wear while awaiting their babies, and my designs filled that need. When I was still working on the gown, orders started to pour in.

I couldn't keep up with the demand. I was secure enough by now to ask Frieda to give up her job with Mr. Schultz and come work for me. She continued to live at Mrs. Bloom's, and I bought a second sewing machine that we squeezed into a corner of my crowded little room. We worked and chatted merrily all day, but when a client came in to be fitted, we were all business. Gradually, blue shadows disappeared from beneath Frieda's eyes, and her sparkle returned. I hadn't seen it since the old days on the *Kaiser Wilhelm*. She had a shorter work day with me, but since I paid her more per hour, she managed nicely.

One Sunday Morris dropped in, bearing a bag of deli sand-

wiches and a bottle of cherry soda. Frieda and I unpacked the food while Morris looked around the crowded little room. He eyed the finished gowns hung four deep on the door frame, and took in the piles of bright fabrics lying in the corners of the floor. Scissors, muslin patterns, drawings, dressmaker's chalk, measuring tapes, boxes of pins, and spools of thread in every color were scattered around the room like a mosaic.

I handed Morris a sandwich, and he sat down in a tiny clear place in the center of the floor.

"That's where my clients stand while I take their measurements," I told him.

He shrugged. "I could have figured that out, Pearl. There's not another spot in the place for a person to stand. And where's that mirror with the oak frame you bought?"

"Over there," I said with a mouth full, pointing. "You just can't see it because I've got all those muslins draped over it. I toss them on the floor when somebody comes in."

"I'm sure that looks professional." He ate quietly for a few minutes.

"Listen, Pearl, can I make a suggestion without you thinking I'm trying to take over your life?"

"Of course." I was sorry that I had hurt him. Still, I thought we understood each other better since I told him how I felt.

"It's time for you to open a shop. Oh, don't look so astonished, Frieda, you know Pearl can do it. You can't do any more in this tiny apartment. Pearl, you shouldn't even be wasting your time taking measurements; anyone can do that. You should be running a shop and working out new designs using the same basic pattern, since it turned out to be such a hit." He reached for his sandwich again.

"Well?"

"Oh, do you think we could, Pearl?" This was timid Frieda, positively twitching with excitement.

I couldn't say a word. A bubble of hope rose, swelled, and filled my throat.

"Well, what do you say, Pearl?"

"I say—I say, let's do it. And pass the cherry sodas, we'll drink to it!"

• • •

Time filled, swelled, and threatened to overflow. Morris knew enough not to run everything, but we asked him to help, and he was delighted. He spent every lunch hour studying the classified ads in the newspaper, and checked out spaces for rent. I spread myself thin, shopping the "Out of Business" sales for store furnishings, working up a mailing list to announce our opening, and making up the patterns in different sizes. Frieda sat cheerfully at the sewing machine all day, putting together garment after garment.

Morris found us a small, narrow store in an area where there was plenty of foot traffic on the street. We moved in the furnishings that he had stored in the basement of his parents' apartment building. I tried to place a tactfully worded ad in the newspaper, but the editor sent it back with a note saying he couldn't possibly publish it; too many readers would consider it indecent. And so I had flyers printed up announcing our opening date, and gave them or sent them to every store in the area.

"*Grand Opening of Pearl's Tea Gowns!* the flyer read. *Ladies, walk in light, not in darkness.* There was a sketch of a woman dressed in a man's bulky shirt silhouetted in the shadows, while above it was a woman in full light. She was wearing my graceful tea gown and just beginning to show her condition.

I gave several flyers to each of the boarders at Mrs. Bloom's, and asked if they would pass them out to everyone they knew. Frieda took a handful to Mr. Schultz's loft and handed them out to all the girls with the same request. Morris went up and down the avenues, especially the ones with fine stores, and placed the announcements in the store windows when the managers would let him.

We worked feverishly right up to opening day. I fell into bed so exhausted every night that I didn't even have the strength to toss and turn and worry about failure. We poured so much hope and energy into the store!

Opening day more than fulfilled our expectations. By three-thirty every dress in stock had been sold. We locked the door and I put a big *Sold Out* sign at the front door, that I printed myself. Morris went out and came back with a bottle of cham-

pagne, which we shared sitting on the floor beneath the empty dress racks.

The three of us were flying high on success, planning our next move, when we heard someone pound on the door.

"Shall I get it?" Morris asked. "Or we could just sit here and ignore it until she leaves."

"Morris, if it's a customer, we have to tell her we're moving into a new location with a larger stock." I clambered up from the floor.

"Such a businesswoman!" he sighed.

The silhouette beyond the glass looked strangely familiar but because the low sun was directly behind her, she was hard to make out. I pulled the door open and the lights from the store fell upon—my aunt.

"*Aunt Heddie!*" I shrieked, too overcome to wonder how she had found me. "Aunt Heddie!" I threw my arms around her neck with the first honest affection I had ever felt for her.

"*Perele!* I knew my heart would lead me!"

She held me out at arm's length and examined me carefully.

"Well, I see this crazy life hasn't hurt you. You look wonderful, darling, roses are blooming in your cheeks, you look like a grown-up young lady now. Oh, Joseph must see you, he's been so worried. Old Mr. Edelman died, I bet you didn't even know that, but...." She looked around at the empty store, at Morris and Frieda, who had risen to their bare feet, at the empty glasses and the half-empty champagne bottle, and she paled. Yes, she actually turned white.

"I think...I think I'm going to...." She clutched at the fastening of her coat.

"Here, ma'am, here's something to sit on," Morris said, fetching the stool that stood behind the cash register. I helped her onto it and unbuttoned her coat, which was too warm for the store, anyway.

"Would you like a sip of champagne, ma'am?" Frieda offered.

"Yes, yes, Frieda, get her some champagne. Oh, I'd like you to meet Aunt Heddie. Mrs. Edelman, these are my friends, Morris Shaw and Frieda Lewitz."

Aunt Heddie took a small sip of champagne. "Oh, that's better," she said.

"I'm just delighted to meet friends of Pearl's. Morris, you couldn't be a boyfriend, could you? Or are you just a friend? Do you know the old saying that there's no such thing as pure friendship between a man and a woman? Romance always gets into it, no matter how hard you try to keep it out."

Morris laughed. "I'm the first to admit, ma'am, that I'd like to be more than a friend. I've been asking Pearl to marry me since I met her, but she...."

"You may as well forget it, Morris," Aunt Heddie broke in with a confiding air. "I know better than anyone, it's impossible to get Pearl to marry. She had a chance to marry my own son, David, a handsome, brilliant boy, who by the way is betrothed now to the daughter of a friend of mine and that's why I came, Pearl, when I saw the flyer. What a good idea, something pretty to wear while you're waiting! I'm hoping they'll start a family right after they marry, although David is still in law school, of course, but it could happen."

"I might have missed you," I said, close to tears. "Why did you keep knocking when we were closed?"

"Because I could hear all this chatter right through the door. I knew there was someone in here, and I didn't believe the sign that says *Sold Out*. How could anyone be sold out on opening day?"

"We can hardly believe it ourselves. Oh, I'm so glad David is going to be married. When the time comes, let me know and I'll make up one of my dresses in the prettiest fabric I can find, for a gift."

"You're a fine one to talk about giving gifts, sitting in an empty store with your friends, no shoes on, drinking champagne. I would ask what you were up to, but I've learned to keep my questions to myself where you're concerned, Pearl."

"But our feet were tired from running to take care of customers all day," Frieda protested.

"Hmmmmph," Aunt Heddie snorted. "We used to have peddlers in Russia who drove their wagons from town to town, selling fabric and notions, pots and pans, anything you needed

for the house. 'You can't sell goods from an empty cart,' that's what they used to say. You might think about that, Pearl."

"The store was full this morning, wasn't it, Frieda?"

"It was. We had so many of Pearl's dresses we could hardly squeeze them on the dress racks," Frieda chimed in.

"There were women here before the door opened at nine o'clock," Morris added. "We had to make the *Sold Out* sign at three-thirty, that's how great Pearl's idea is."

"*Pearl's idea?* You mean these tea gowns are *Pearl's idea?*"

"Yes," I said. "My own idea."

She fluttered her lashes and fanned herself with the collar of her coat. "I could pass out," she said, and fanned more vigorously.

"But Perele, why didn't you say you wanted to design dresses? I have friends who are so exclusive they go to a designer for every dress they wear. We would have found a designer you could study with. You didn't have to break our hearts and your father's heart, who is so all alone in the world and a bitter old man...."

"Oh, he was a bitter old man even when he was a young man," I cried. "He was never the same after my mother died; Aunt Rachel told me. She's the only family I ever had."

I stopped, horrified by what I had just said.

"And aren't we your family?" Aunt Heddie screamed, flushing. "Didn't I do everything I could? Find you tutors, buy you clothes—by the way, the two trunks you left are in the basement, do you want them?"

I put my arms very gently around my aunt and kissed her lightly on the cheek.

"I never said 'thank you' for all you did for me. I'm saying it now, with all my heart. Thank you. In a way, I loved you, but I had to get out. You were smothering me with kindness."

"Well." She shook her shoulders like a hen settling her feathers, and smiled, or rather beamed, at me. For some reason, Frieda and Morris beamed, too.

"But you haven't told me about father. Is he well? I know he sold his business, Aunt Rachel wrote me before she...before she died. What does he do now?"

"I have to tell you, I don't think he does anything but brood on his sorrows. He is a bitter man, and we had a quarrel after you left. I wrote to him and asked him if he had heard from you, and asked him for your address if he knew it. He wrote back and said he had heard from you, but as far as he was concerned you no longer existed, and how could he send the address of someone who doesn't exist? So I wrote him a letter to shame him; a daughter is a daughter, after all. But he sent me a very angry answer, and I haven't written to him since. A nice dish of noodles all this has come to."

"I'm sorry. Aunt Heddie, I'm sorry I left your house like that, it was a rotten thing to do."

"Mrs. Edelman, if you don't have to go home, would you like to join us for dinner?" Morris asked. "Pearl and Frieda have so much to celebrate, I thought I'd take them out to a Chinese restaurant."

She glowed with pleasure. "Well...."

"Morris has something to celebrate, too," I announced. "He's going to be married."

"Married!"

Aunt Heddie jumped off the stool and grabbed me in one of her frantic embraces. "No, no, children, you must come home with me for dinner. Oh, it will do Joseph's heart good to see you, such lovely young people, he's been so gloomy since his father died. And a wedding, I'll plan the finest wedding in New York. We're planning two hundred people for David's wedding. Morris, do you have a family here? I want to meet them."

I wiggled out of her arms. "Aunt Heddie, this is my wedding. Or rather it's our wedding," I protested. "I think *we* should decide what kind of a wedding it will be."

I held out my hand to Morris.

"Dearest Pearl!" he said. He gathered me in his arms for a kiss that sealed my promise.

In an abundance of good will, Aunt Heddie seized Frieda to her broad bosom and kissed her soundly on both cheeks. "You will eat well at my table," she said to Frieda, "and often. The house is empty with David at law school, and the other boys growing up so fast. Morris, let go of Perele already, you have

the rest of your lives for that. We must start home, I have to tell Zivia we're having company."

"Why don't you go along, and we'll come to your house after we wash up," Frieda suggested.

"I wouldn't dream of it," Aunt Heddie said. "It took me two years to find Pearl again. Do you think I'm going to let her go just like that?"

Morris looked at me, and I looked at Frieda. We smiled at each other. Then we tied our shoes and went with Aunt Heddie to join the rest of our family.